DRAW 50
PEOPLE
OF THE BIBLE

BOOKS IN THIS SERIES

DRAW 50 PEOPLE OF THE BIBLE

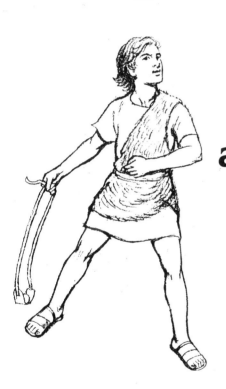

**Lee J. Ames
and André Le Blanc**

BROADWAY BOOKS
NEW YORK

BROADWAY

Published by Broadway Books
a division of Random House, Inc.
1540 Broadway, New York, New York 10036

BROADWAY BOOKS and it's logo, a letter B bisected on the diagonal, are
trademarks of Broadway Books, a division of Random House, Inc.

Library of Congress Cataloging-in-Publication Data

Ames, Lee J.
 Draw 50 people of the Bible / Lee J. Ames and André Le Blanc.
 p. cm.
 "A Main Street book."
 1. Bible—Illustrations. 2. Portrait drawing—Technique. I. Le
Blanc, André, 1921– . II. Title.
NC773.A47 1995 95-24361
743′.884—dc20 CIP
ISBN: 0-385-47162-9
TEXT AND ILLUSTRATIONS © 1995 BY LEE J. AMES AND MURRAY D. ZAK
ALL RIGHTS RESERVED
PRINTED IN THE UNITED STATES OF AMERICA
FIRST MAIN STREET BOOKS EDITION: NOVEMBER 1995

9 8 7 6 5 4

Introduction

André Le Blanc and I were born eight days apart in January 1921.

As a young man, André studied at the renowned Art Students League in New York City, the launchpad for many celebrated artists. He completed his schooling during the Great Depression, and at first was able to find work only as a designer of business window displays.

When André discovered the new, fast-growing field of comic magazines, he joined the legendary "Eisner-Iger Shop," a studio that employed many young cartoonists. A number of these would go on to become well-known superhero artists. Shortly after, I, too, joined the shop. That was when our friendship began. We have maintained a close, brotherly relationship ever since. During these many years we both moved into advertising, magazine illustration, book illustration, and teaching. We collaborated on numerous occasions when our paths crossed professionally. Through the years our deep friendship extended to and encompassed our wives and kids. Now, once again, we join forces on these pages.

André and his wife, Elvira, have spent much of their married life as world travelers. This they have accomplished by tramp steamer, railroad, bus, and camelback from India to Brazil, and many places in between. It was as a working correspondent for a major Brazilian newspaper that André went to India. There he became irresistibly fascinated with the land, its people and religions. In Goa, the Portuguese enclave in western India, pilgrims gathered from all over the world at the great cathedral in Pangim. There the body of Saint Francis Xavier was to be displayed for the last time in 400 years. André reported this major story to his newspaper back in Brazil. During this period, in 1952, Christians, Buddhists, Hindus, and Muslims lived side by side in peace under a tolerant Portuguese administration. André's continuing press coverage revealed this positive side of the administration, in contrast to the usual negative criticism in the world press.

As a result, André's articles and drawings were prominently featured in *O Globo*, the most important newspaper in Rio de Janeiro. The stories also appeared in the London *Times* and in *Life* magazine in the United States. From Goa, André continued his travels as far east as Calcutta, then back to Bombay and on to Pakistan, before returning to the States.

Back at home his portfolio impressed many art directors. As a result, he began working as an illustrator of Bible subjects, and over the years has received extensive acclaim for the work he has produced. For many years his 900-page *Picture Bible* has been an international best-seller.

LEE J. AMES

An Additional Note

When you start working, use clean white bond paper or drawing paper and a pencil with moderately soft lead (HB or No. 2). Keep a kneaded eraser handy (available at art supply stores). Choose the subject you want to draw. Try to imagine the finished drawing on the drawing area; then visualize the first steps so that the completed picture will fill the page—not too large, not too small. Now, very lightly and very carefully, sketch out the first step. Also very lightly and carefully, add the second step, the third step, and so on. As you go along, study not only the lines but the spaces between the lines. Remember that the first light steps must be sketched with the greatest care. A mistake here could ruin your final drawing.

As you work, it's a good idea to hold a mirror to your sketch from time to time. The image in the mirror frequently shows distortion you might not recognize otherwise. In the book, you will notice that new step additions (in color) are printed darker. This is so they can be clearly seen. But you should keep your construction steps always very light. Here's where the kneaded eraser can be useful. You can lighten a pencil stroke that is too dark by pressing on it with the eraser.

When you've completed all the light steps and you're sure you have everything the way you want it, finish your drawing with firm, strong pencil strokes. If you like, you can go over it with India ink (applied with a fine brush or pen) or with a permanent fine-tipped ballpoint pen or felt-tipped marker. When the drawing is thoroughly dry, you can then rub the kneaded eraser over the entire surface to clean out all the underlying pencil marks.

Remember, if your first attempts at drawing do not turn out the way you'd like, it's important to keep trying. Your efforts will eventually pay off and you'll be pleased and surprised at what you can accomplish. I sincerely hope that, as you follow our techniques, your skills will improve. Mimicking the way André and I work, exercising your thinking tools, can open the door to your own creativity. We hope that you will enjoy our drawing concepts of People of the Bible.

L.J.A.

DRAW 50
PEOPLE
OF THE BIBLE

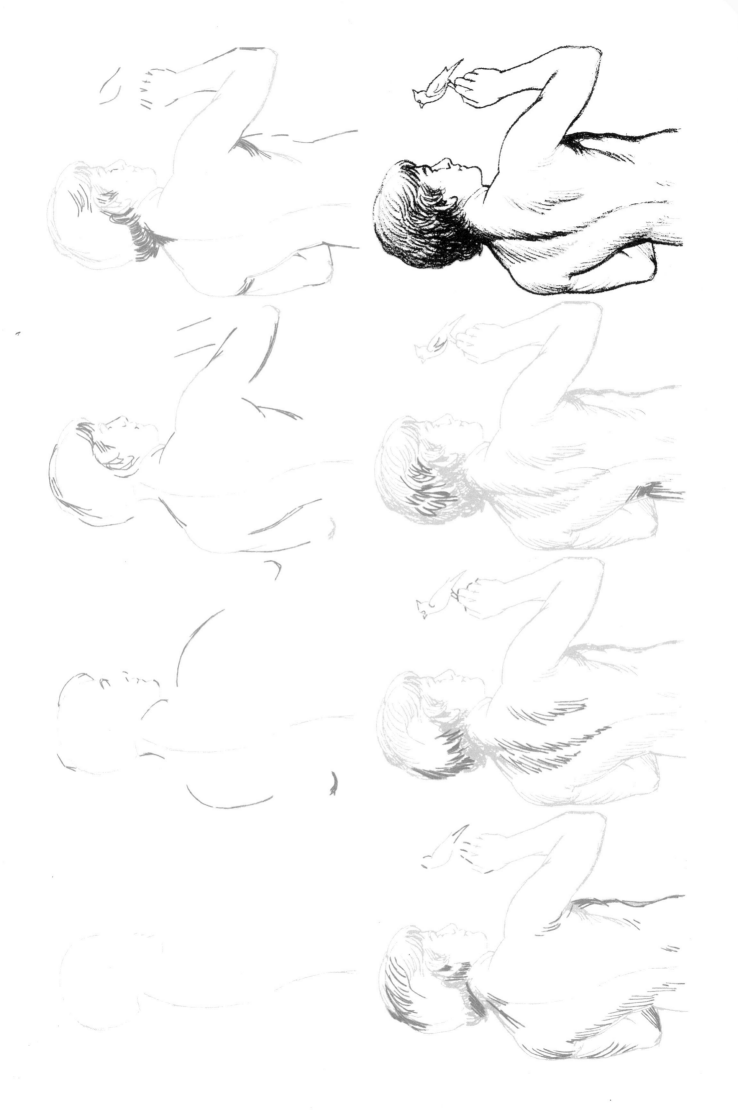

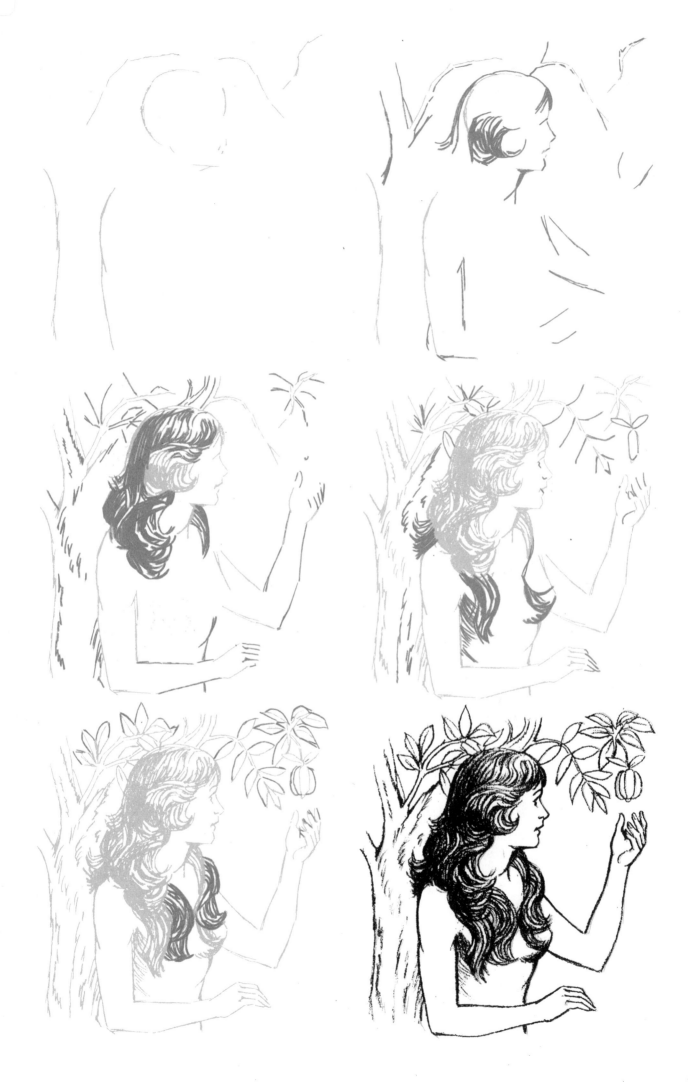

Eve (Genesis 3:6)

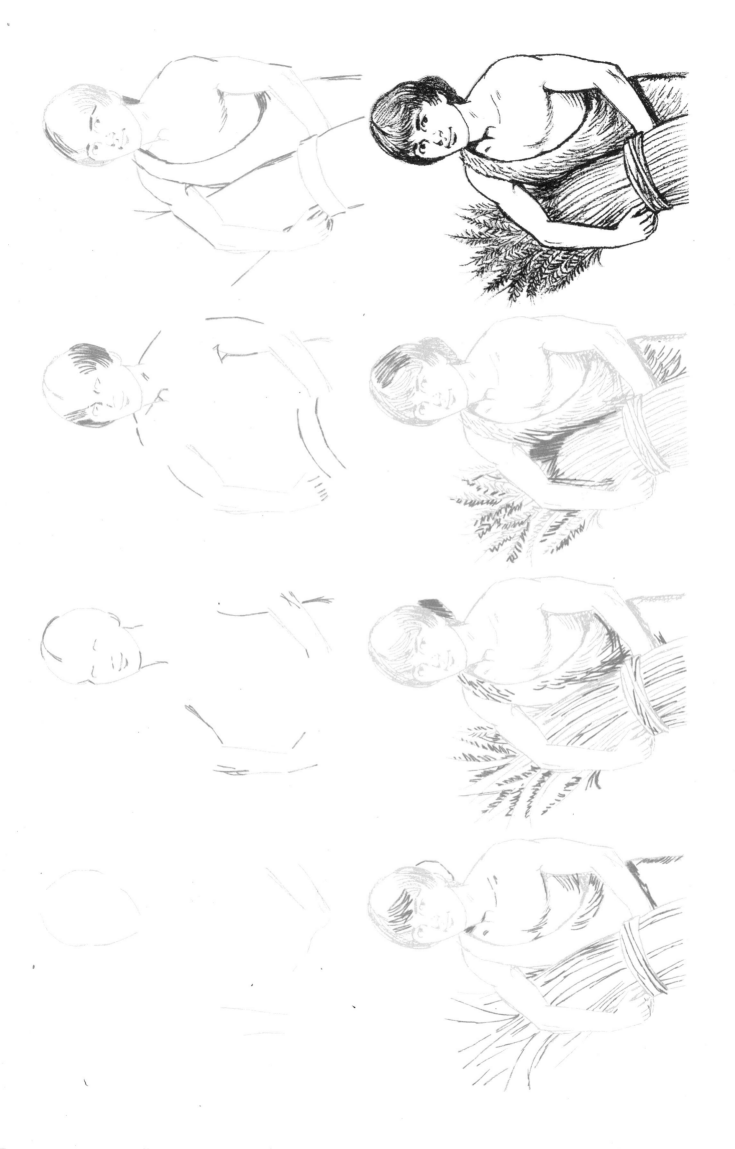

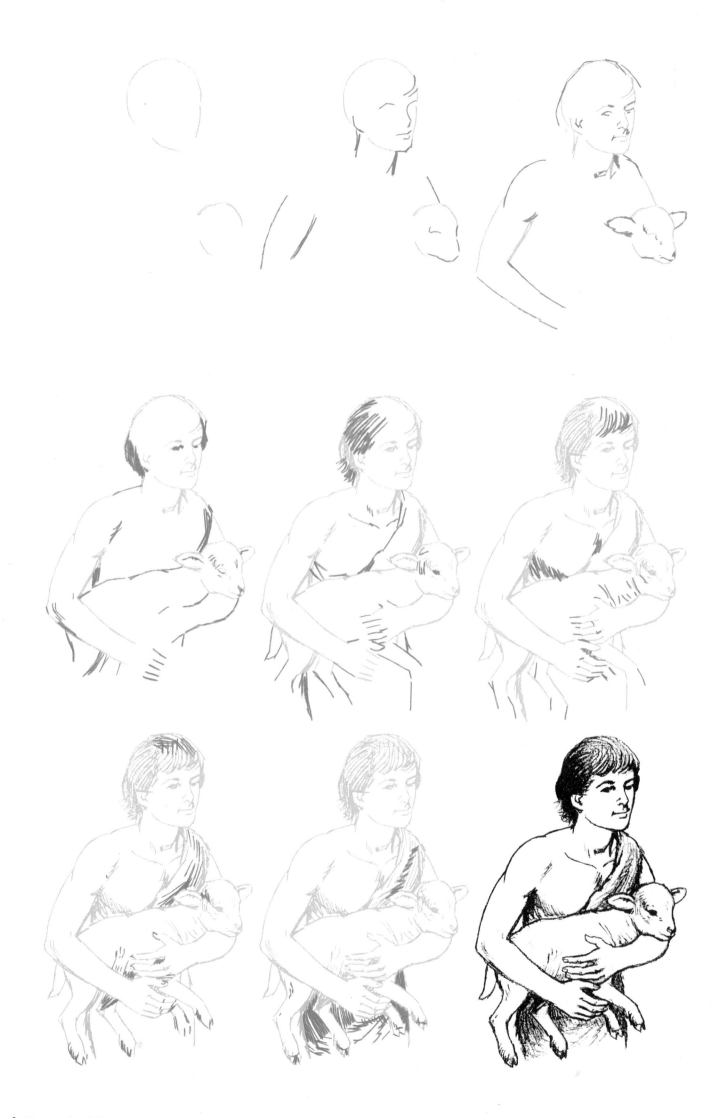

Abel (Genesis 4:2)

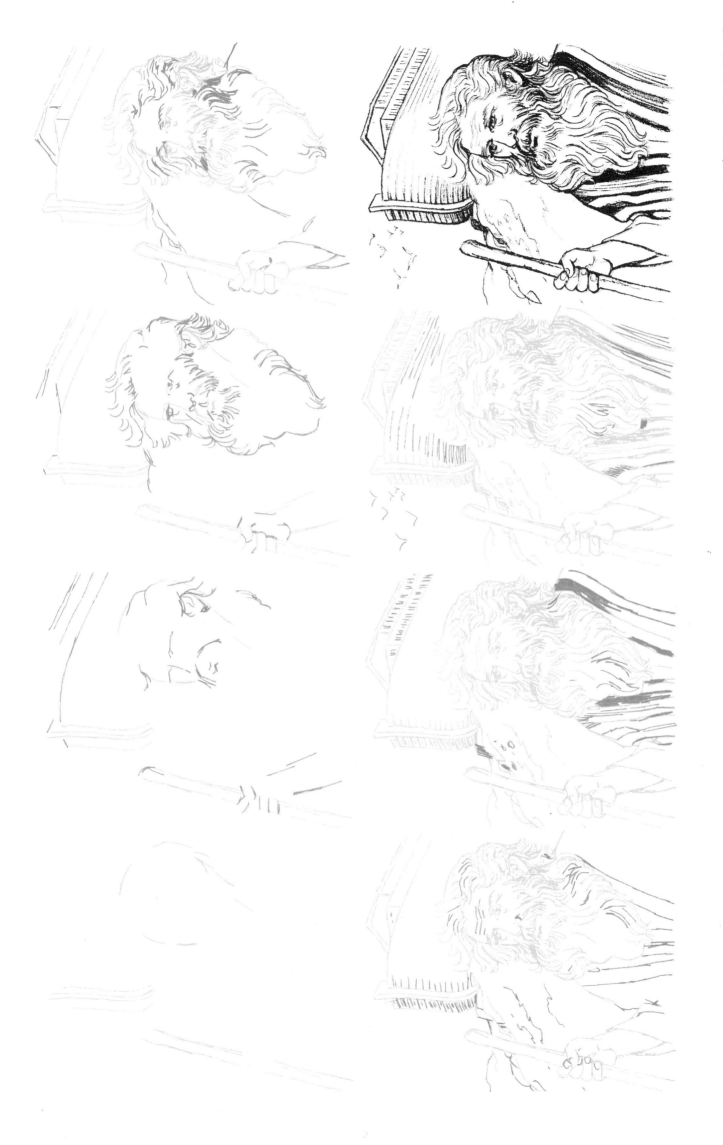

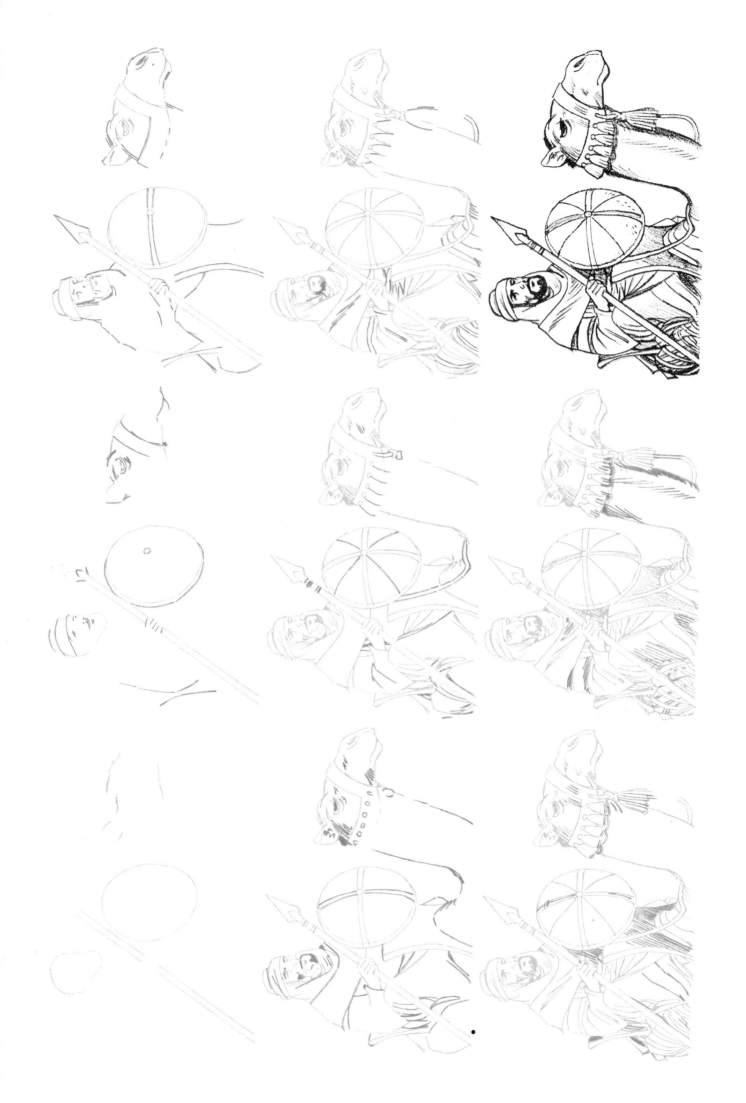

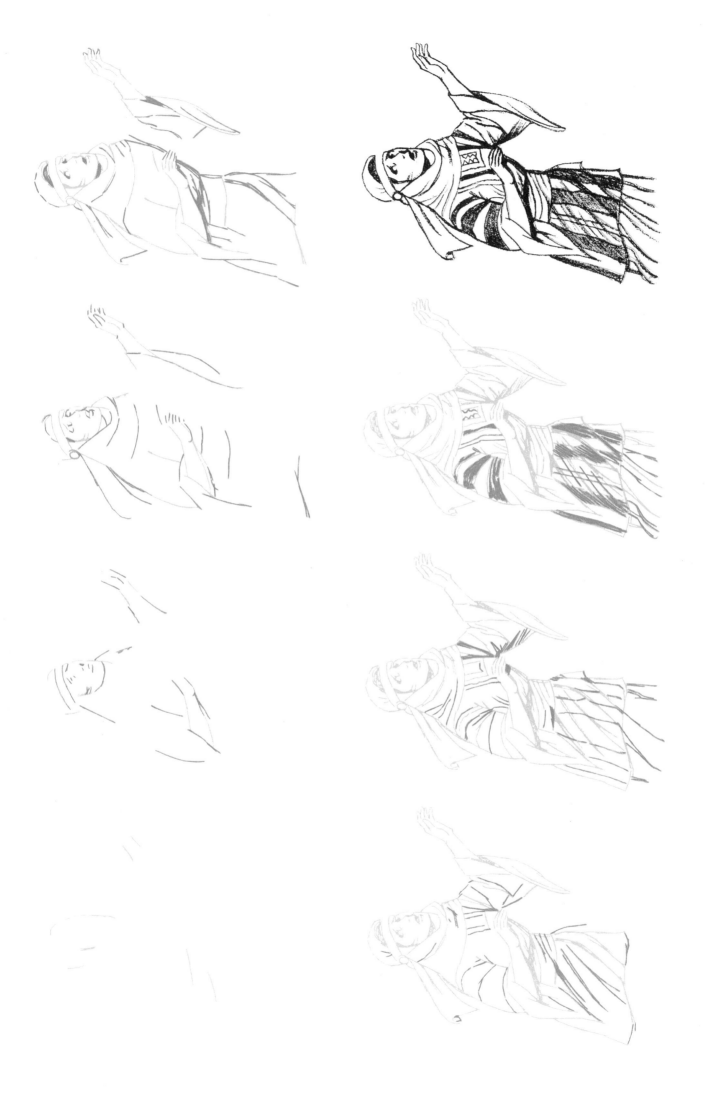

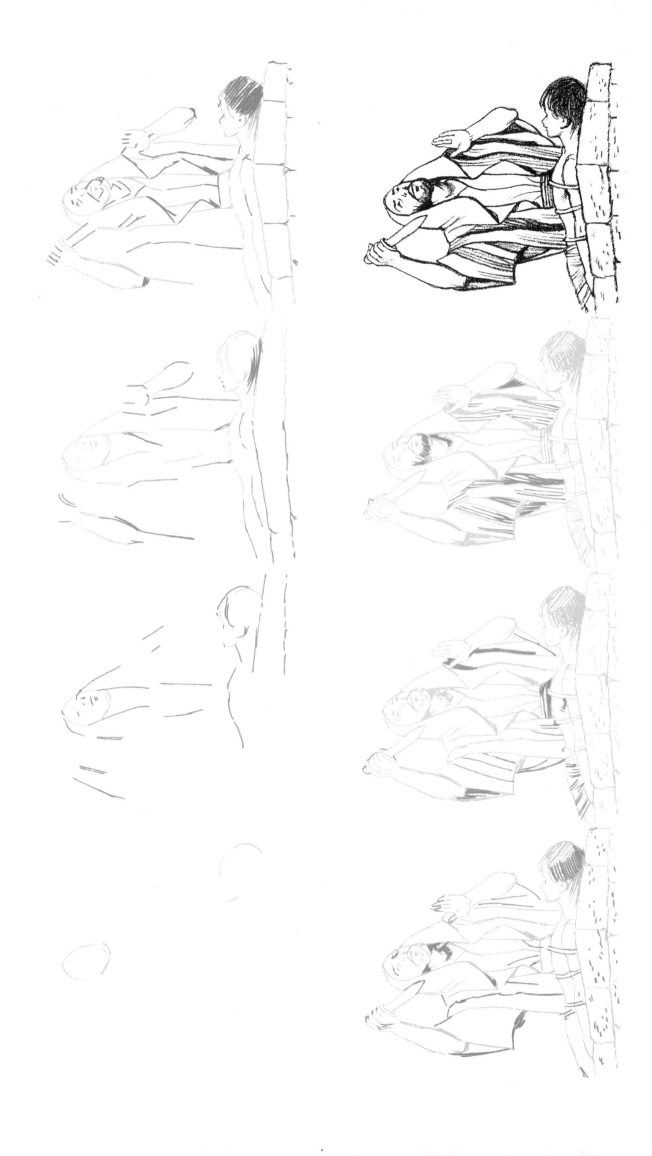

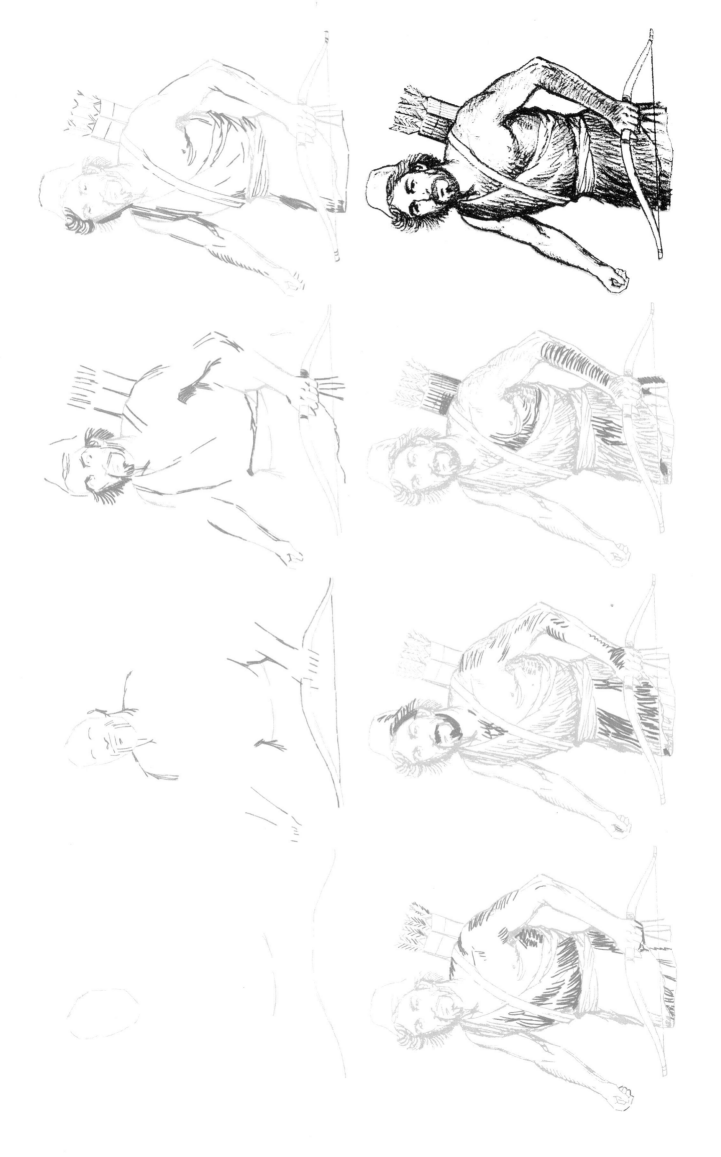

Esau (Genesis 25:27)

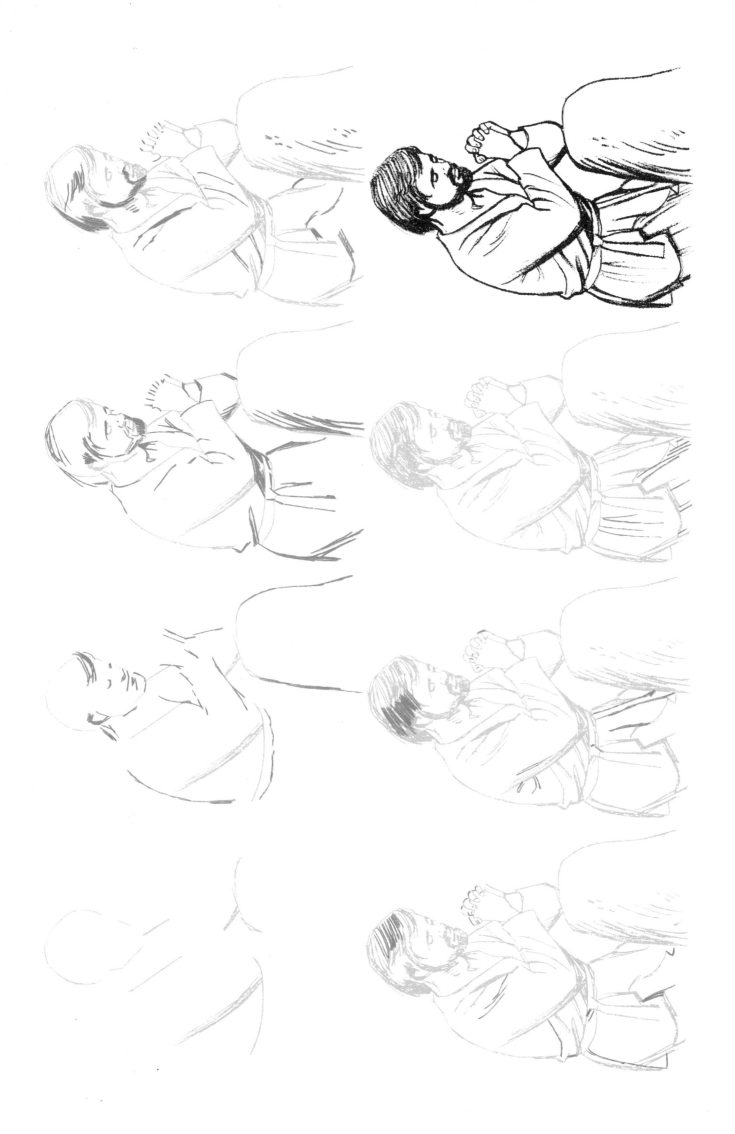

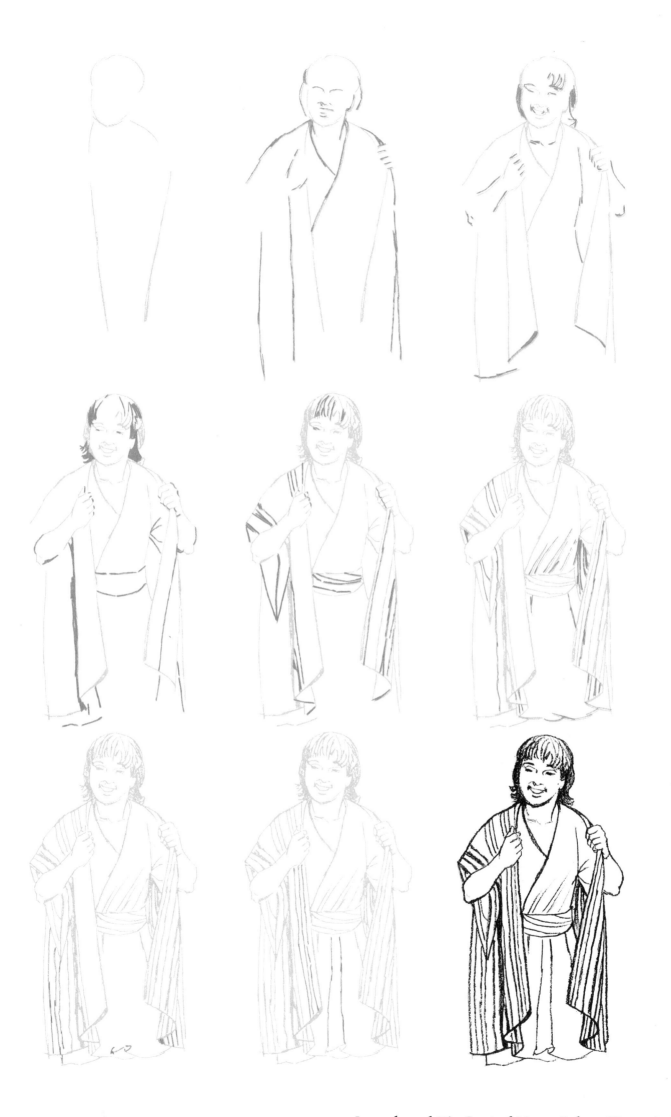

Joseph and His Coat of Many Colors (Genesis 37:3)

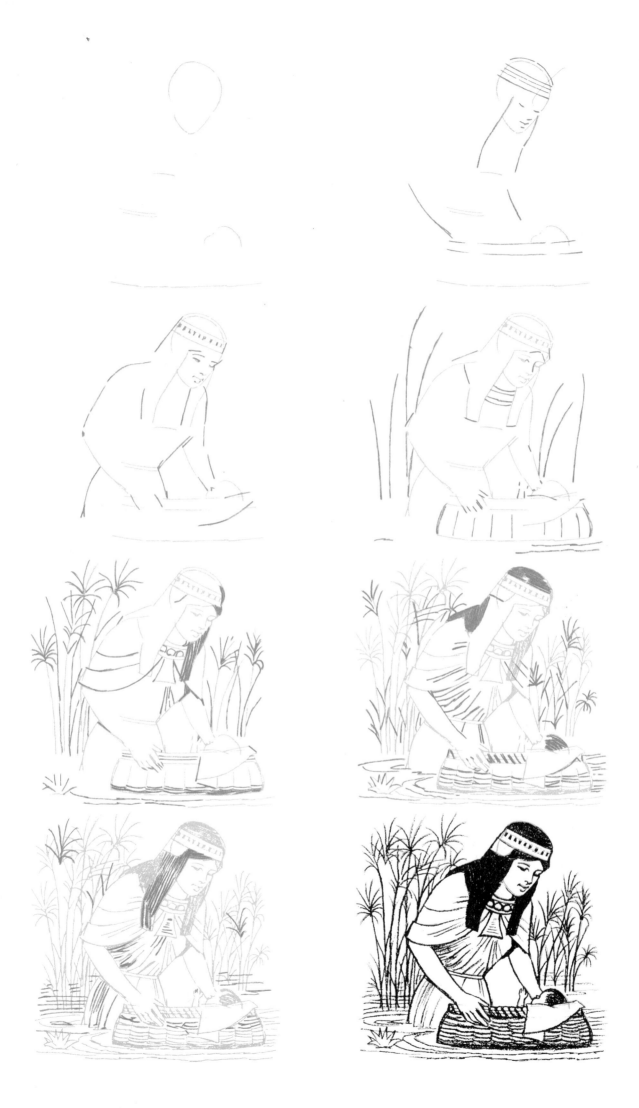

Pharaoh's Daughter (Exodus 2:5—6)

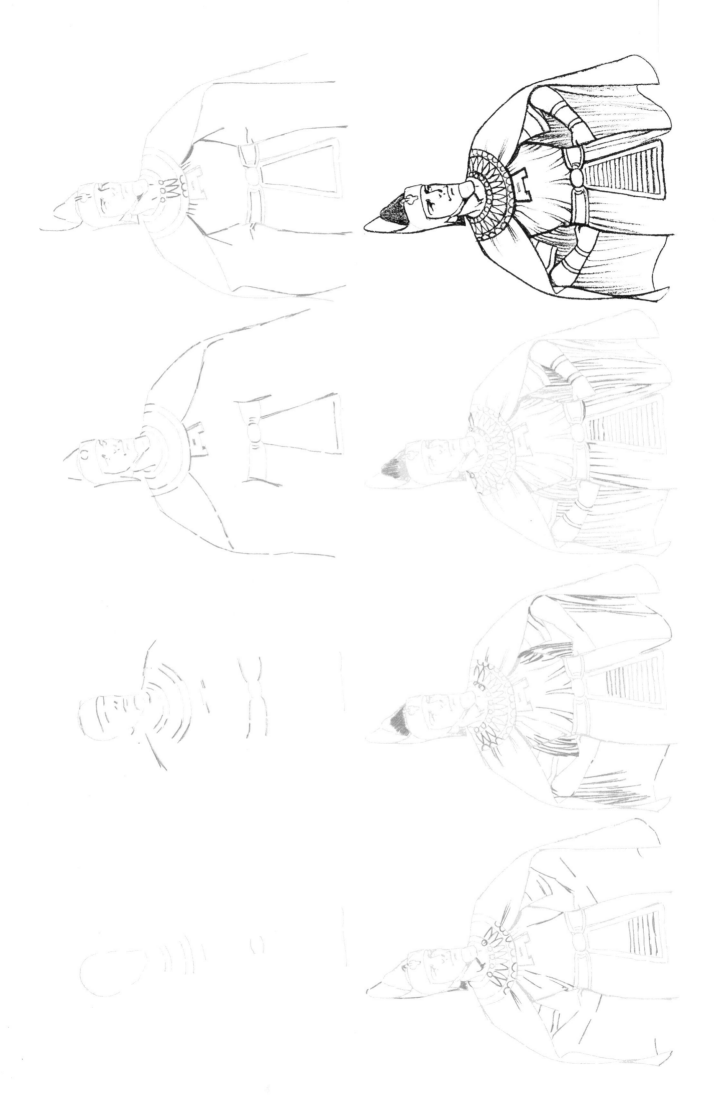

Pharaoh (Ex

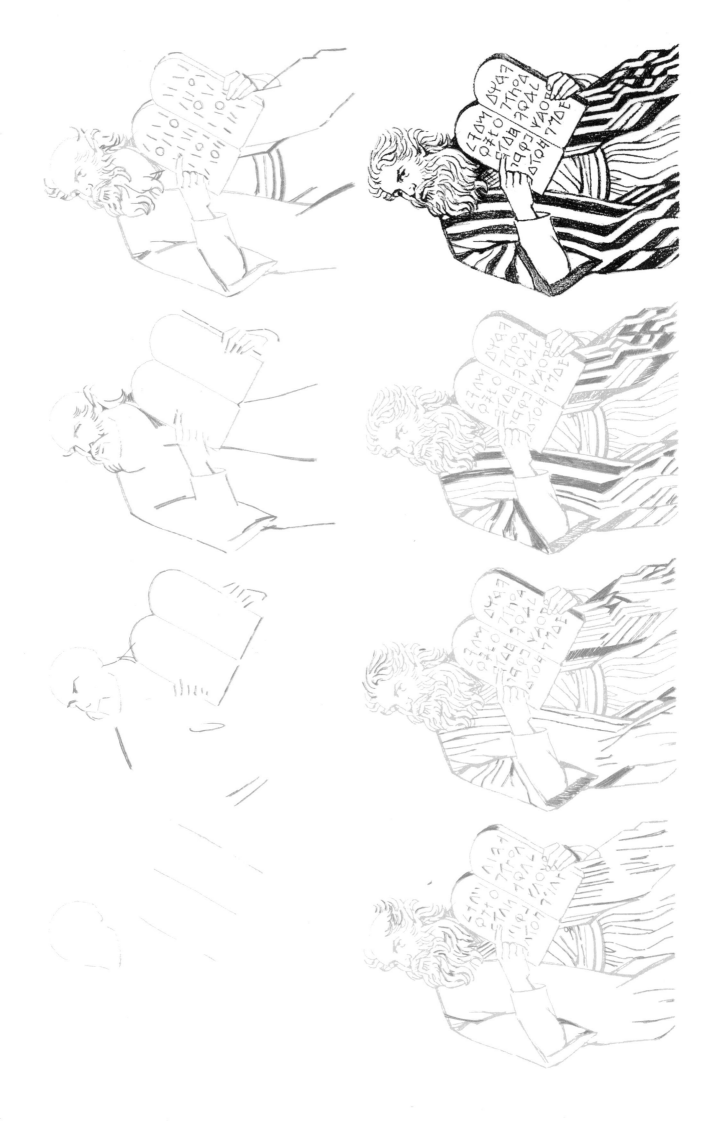

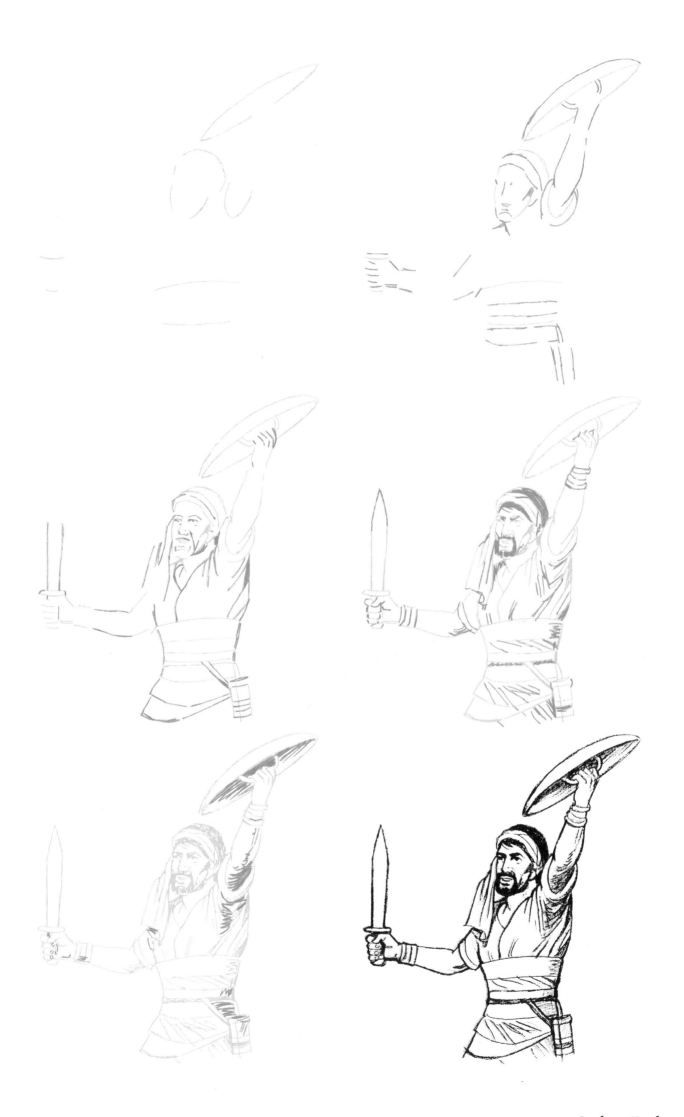

Joshua (Joshua 8

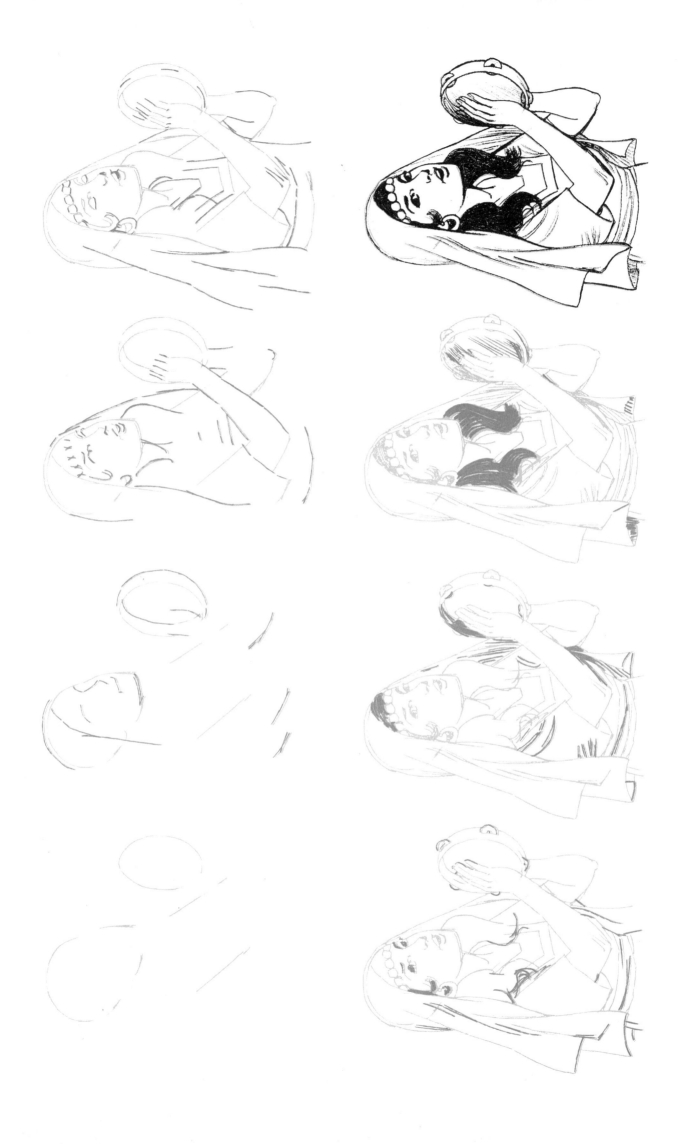

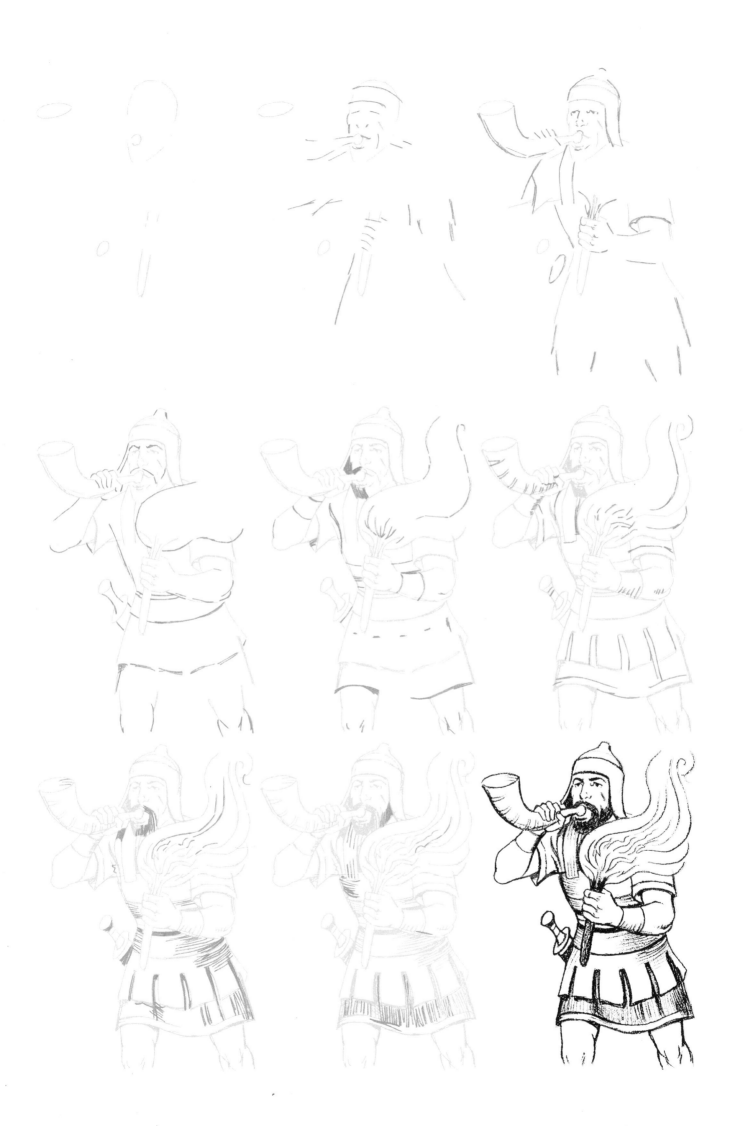

Gideon (Judges 6:34)

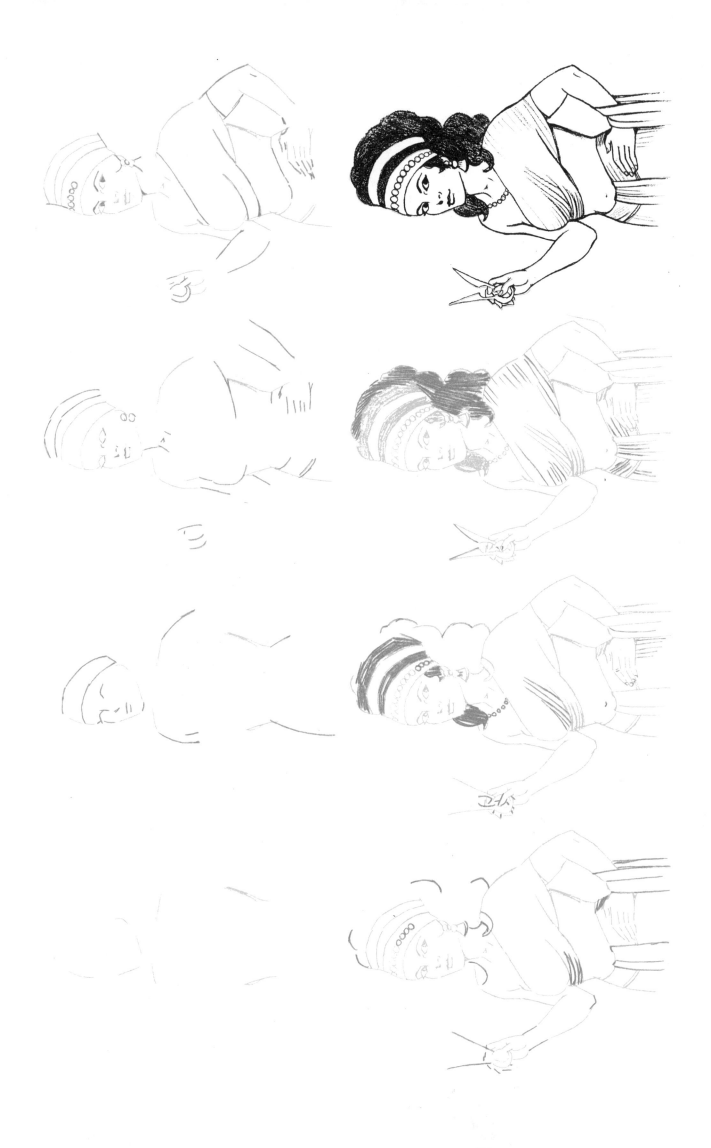

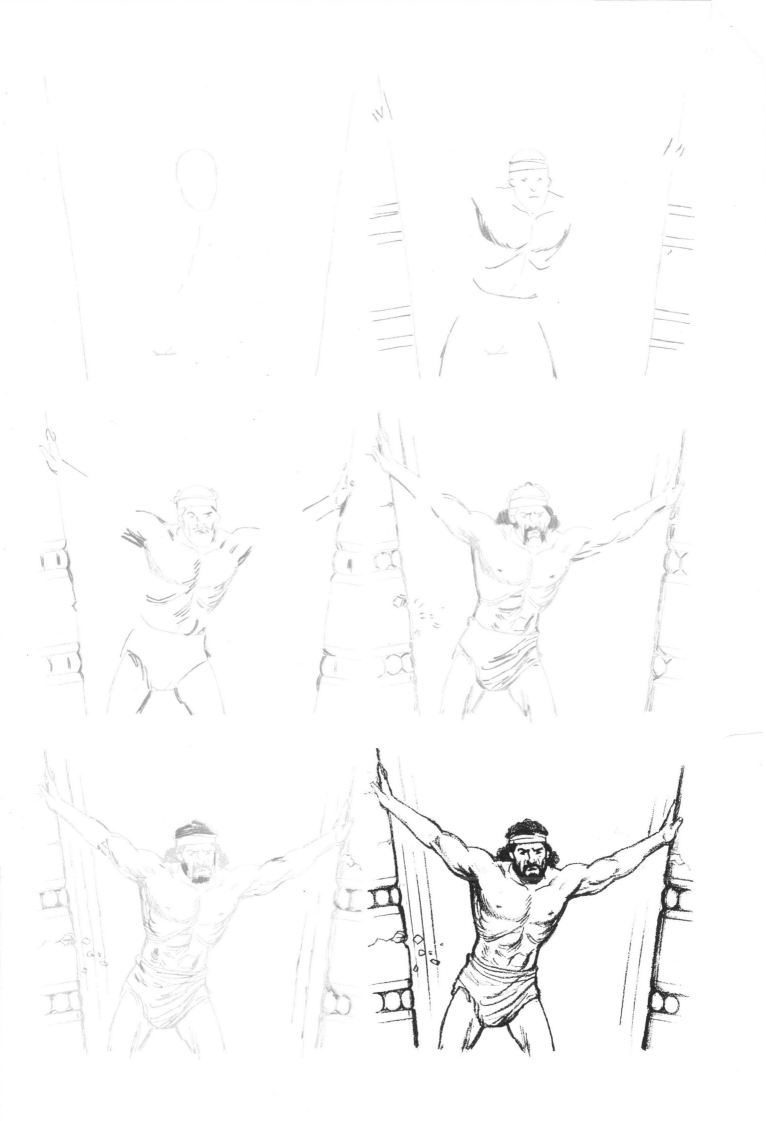

Samson (Judges 16:29)

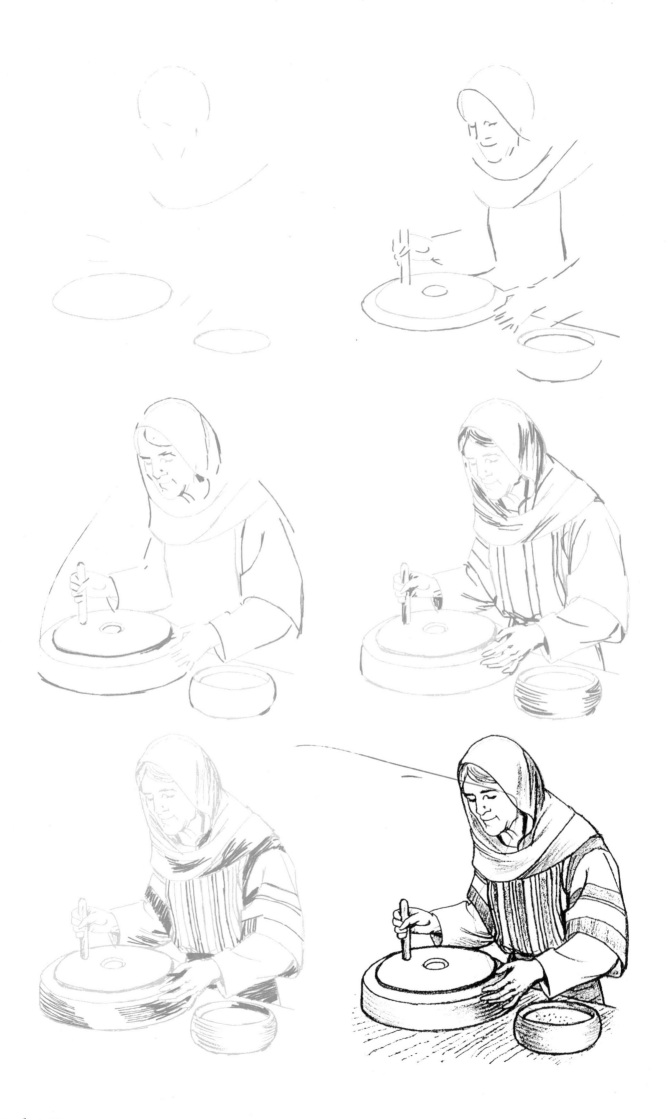

Naomi (Ruth 1:2)

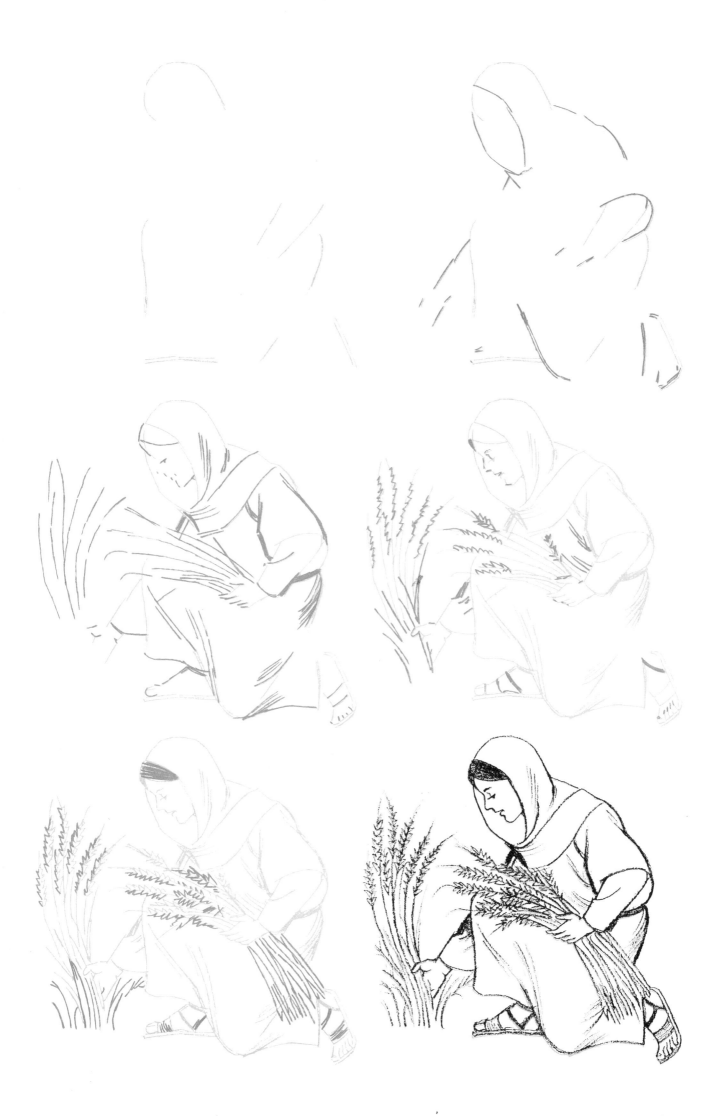

Ruth (Ruth 2:3)

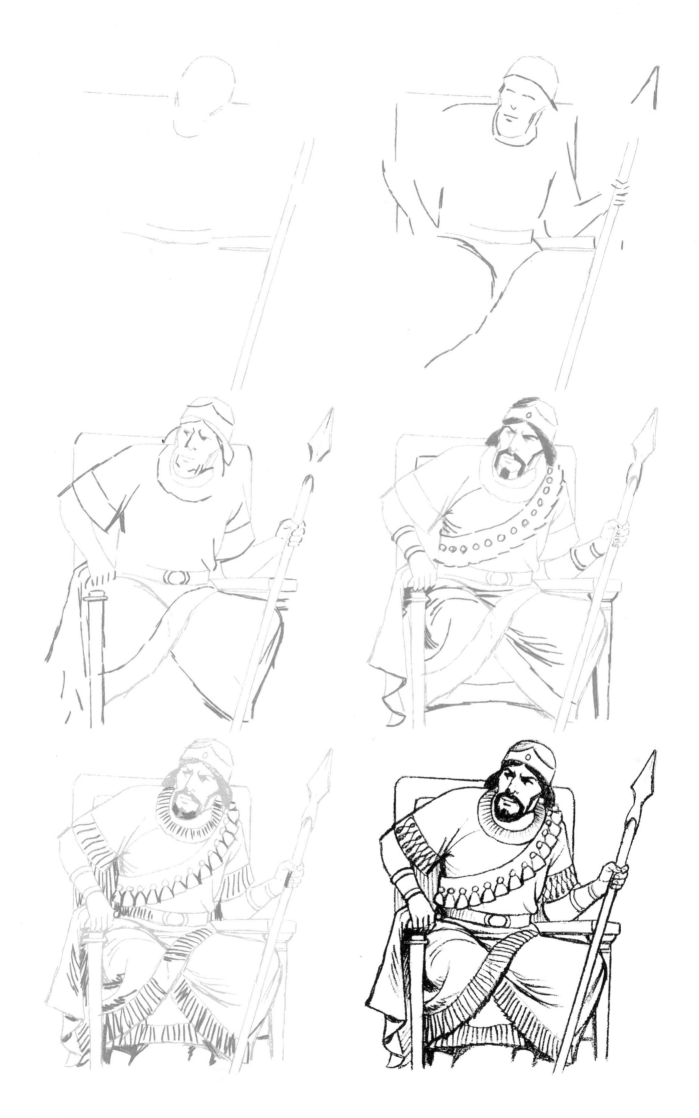

King Saul (I Samuel 14:47)

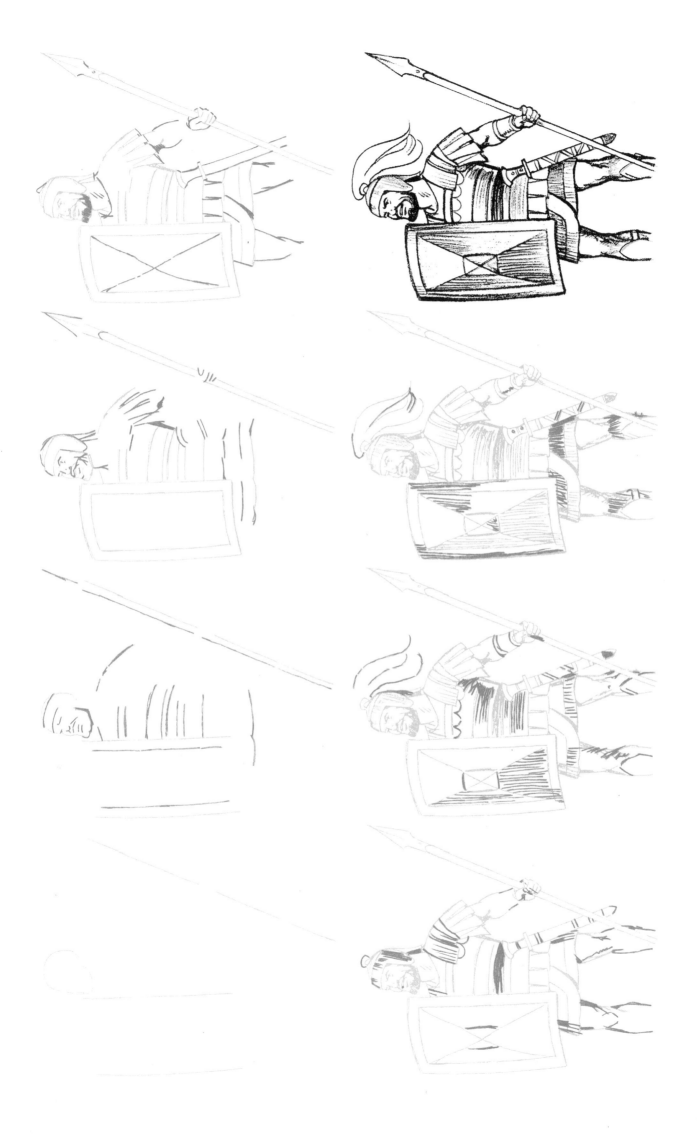

Goliath (I Samuel 17:4)

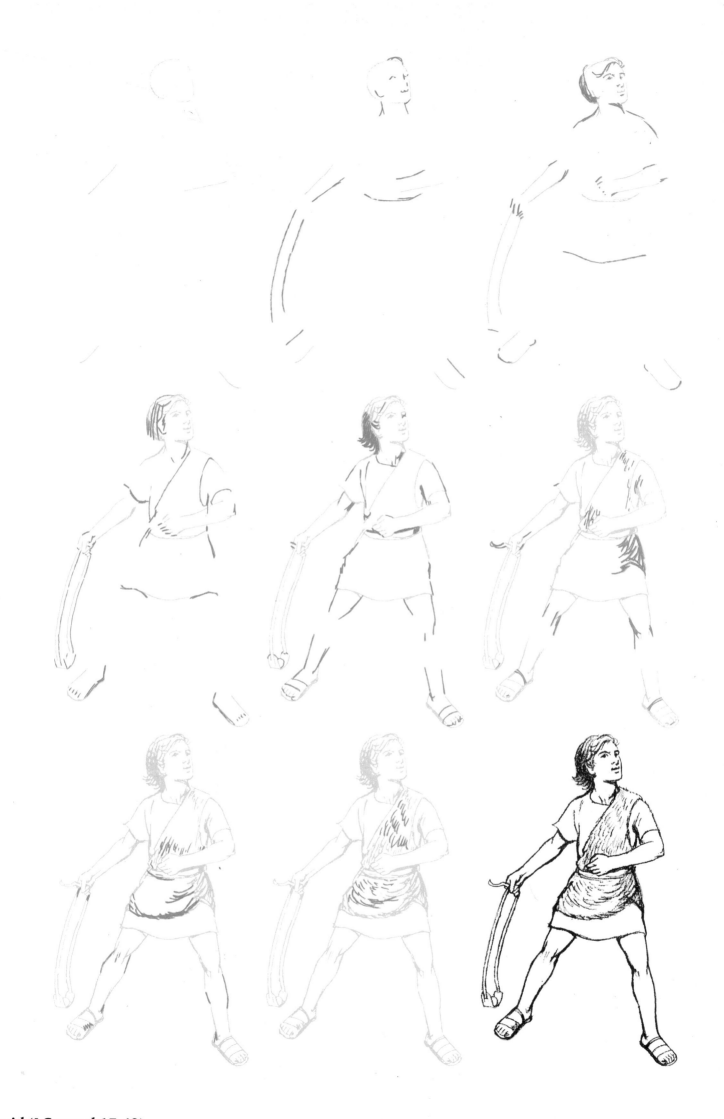

David (I Samuel 17:49)

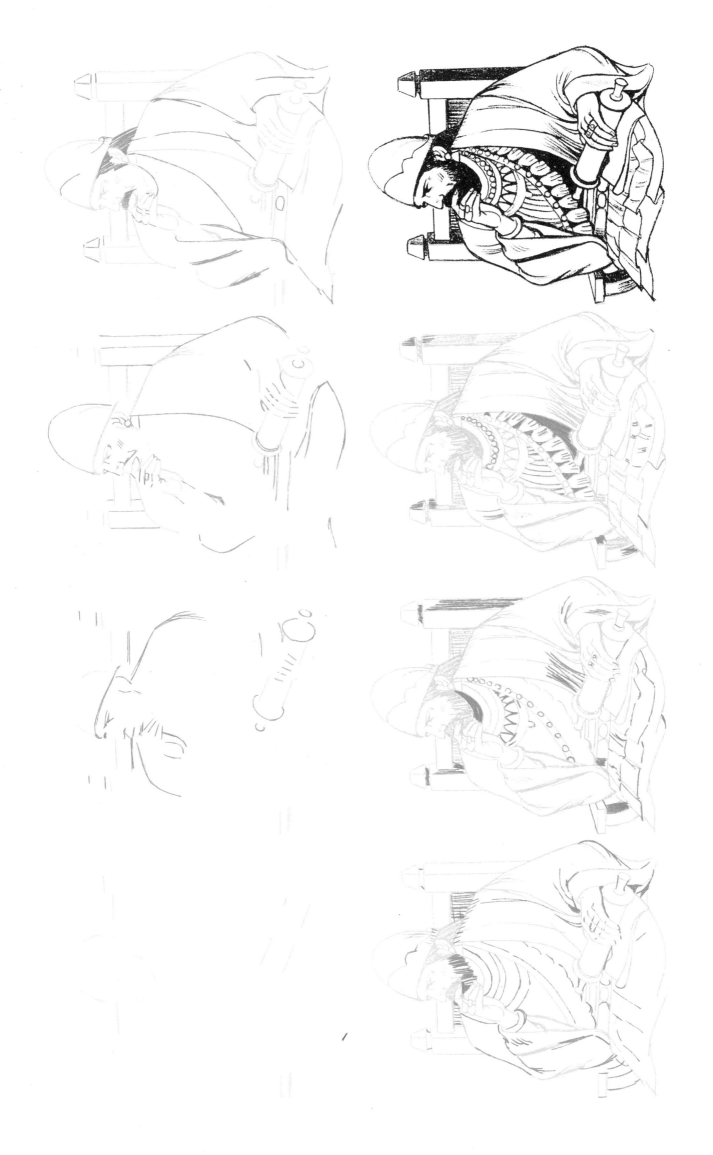

King Solomon (I Kings 4:29)

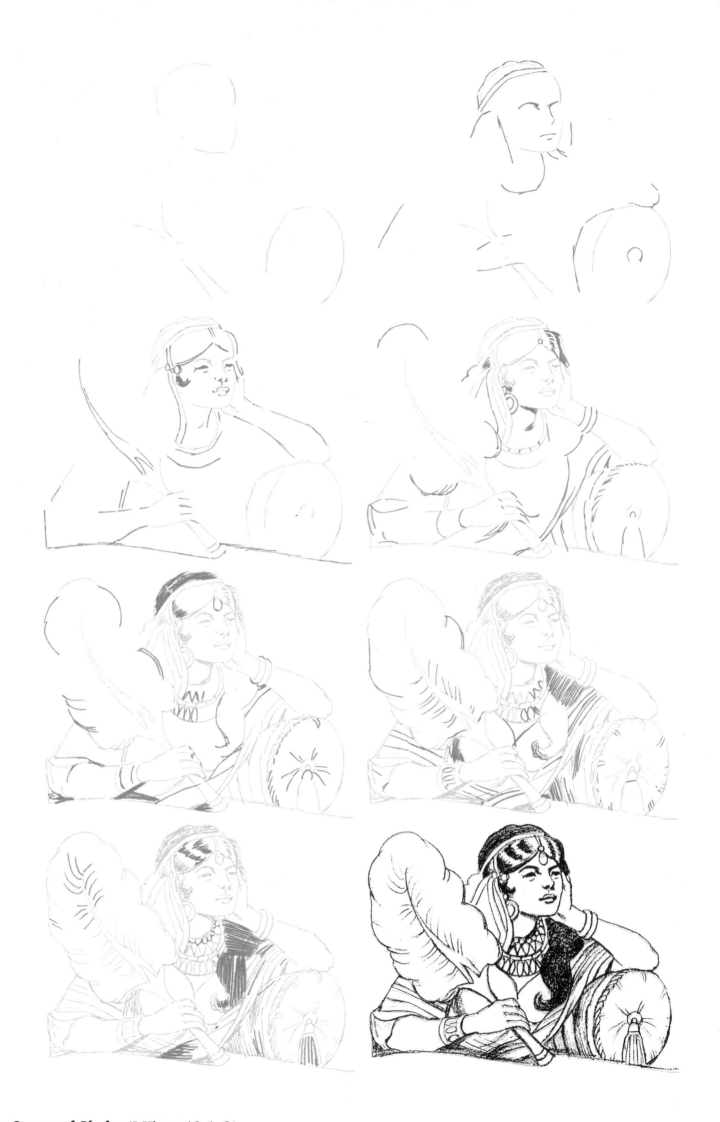

The Queen of Sheba (I Kings 10:1–2)

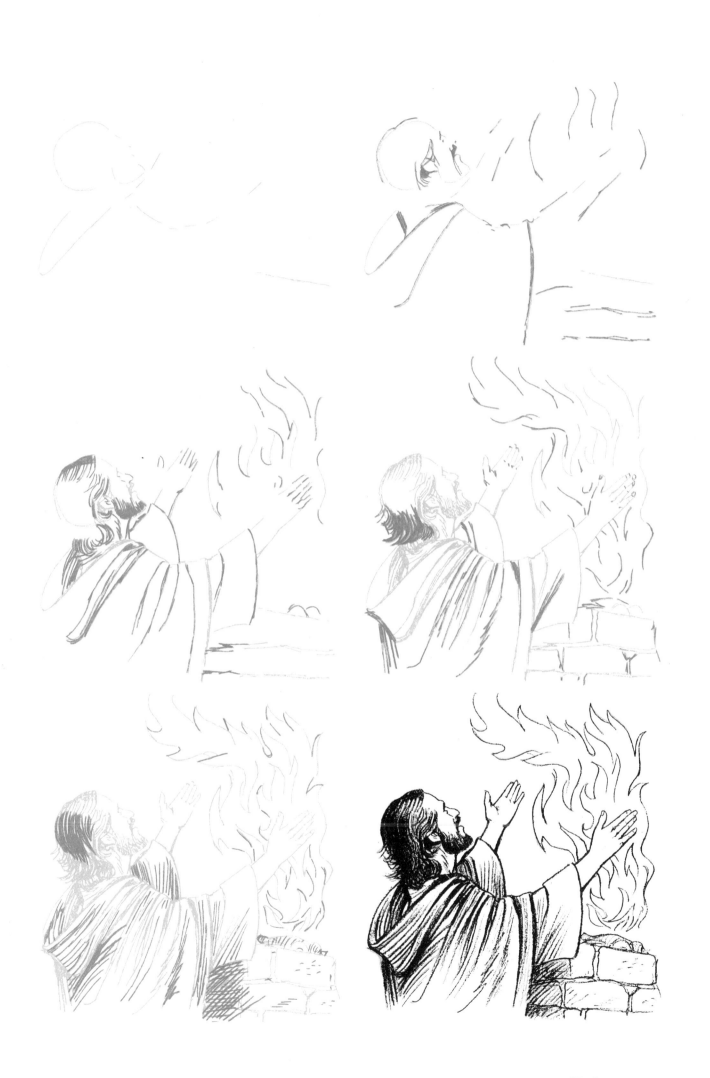

Elijah (I Kings 18:29–38)

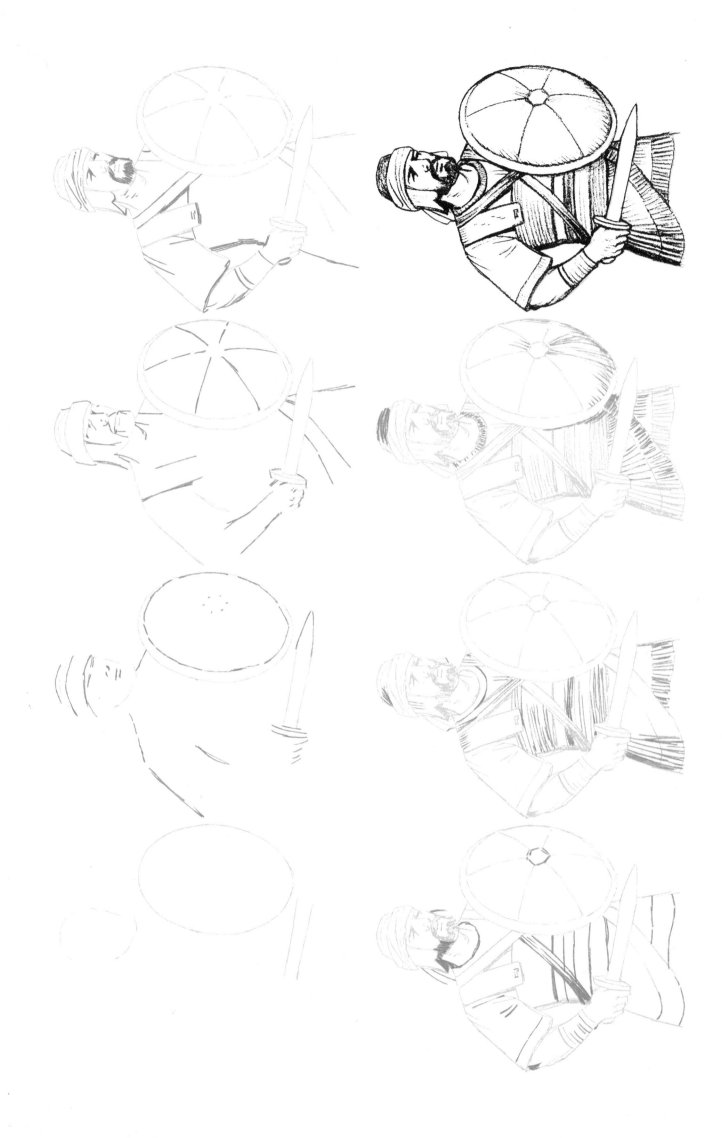

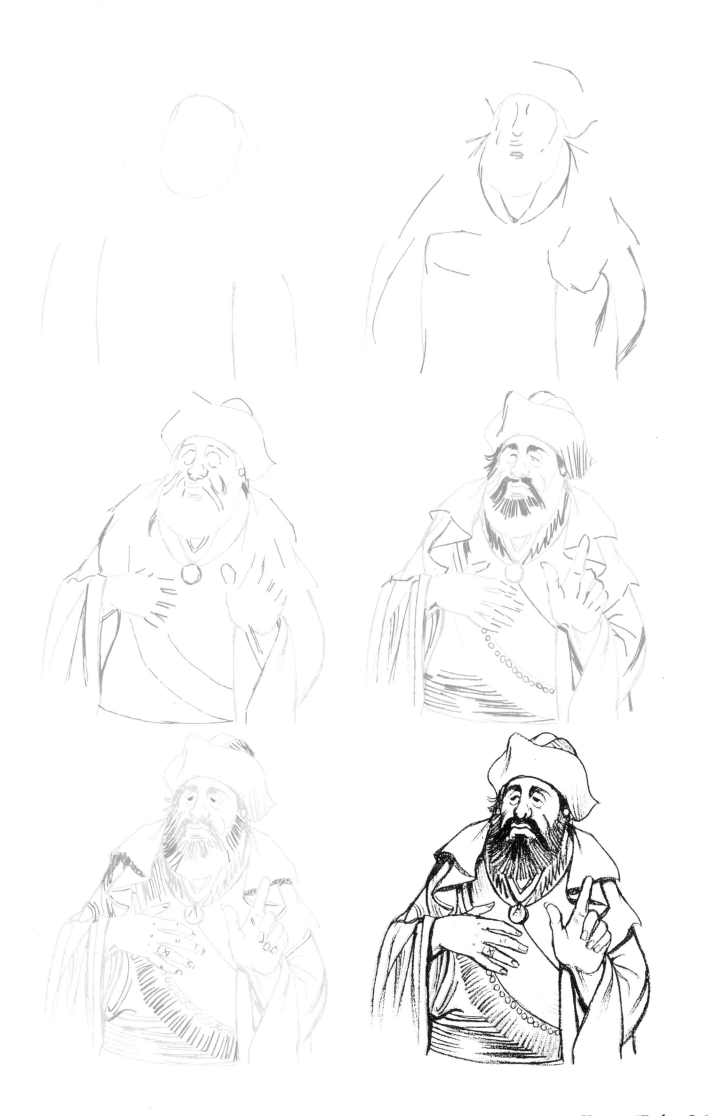

Haman (Esther 3:1–5)

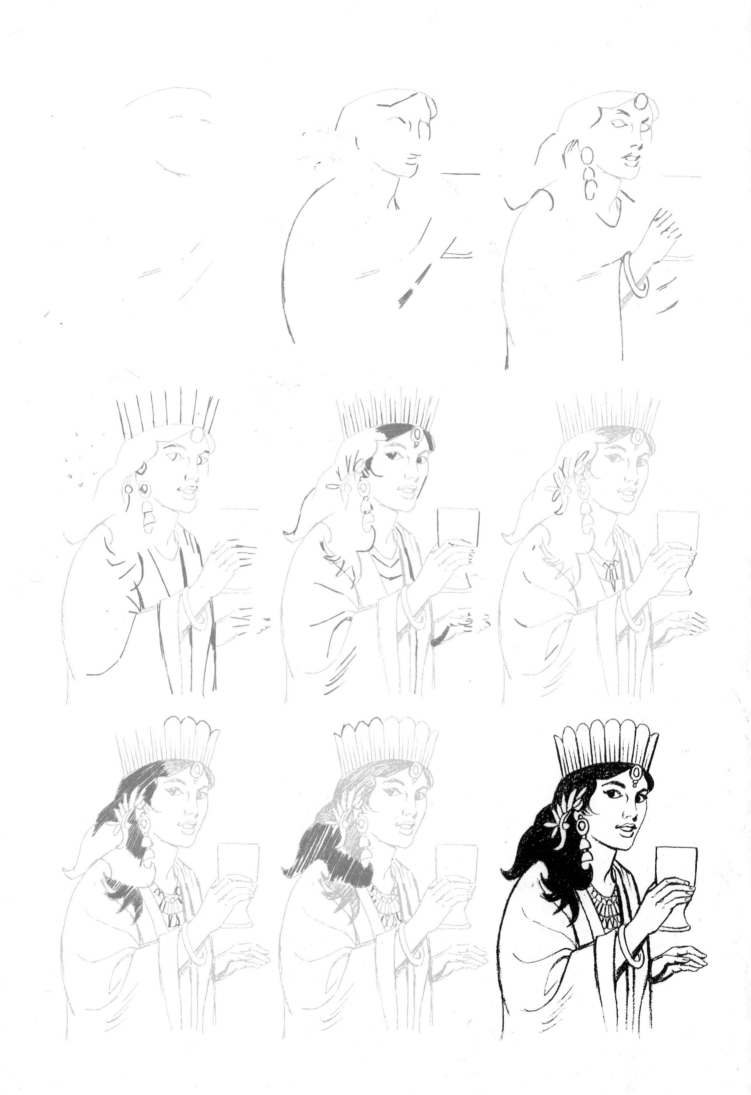

Queen Esther (Esther 7:1–2)

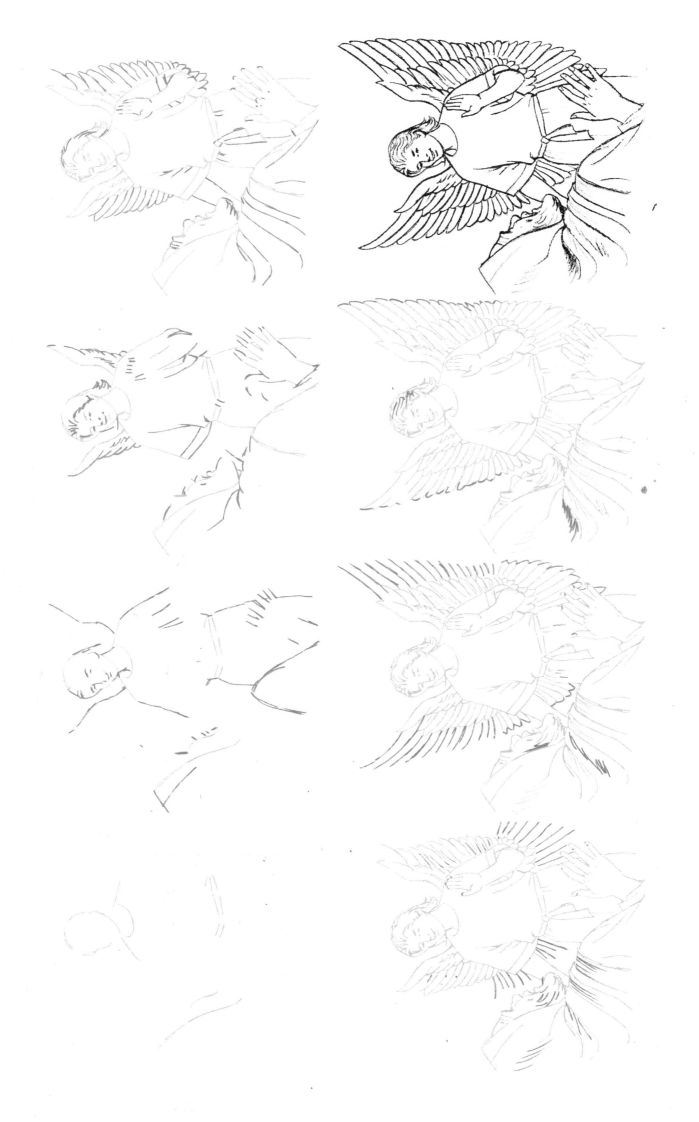

Ezekiel and an Angel (Ezekiel 1:4–5)

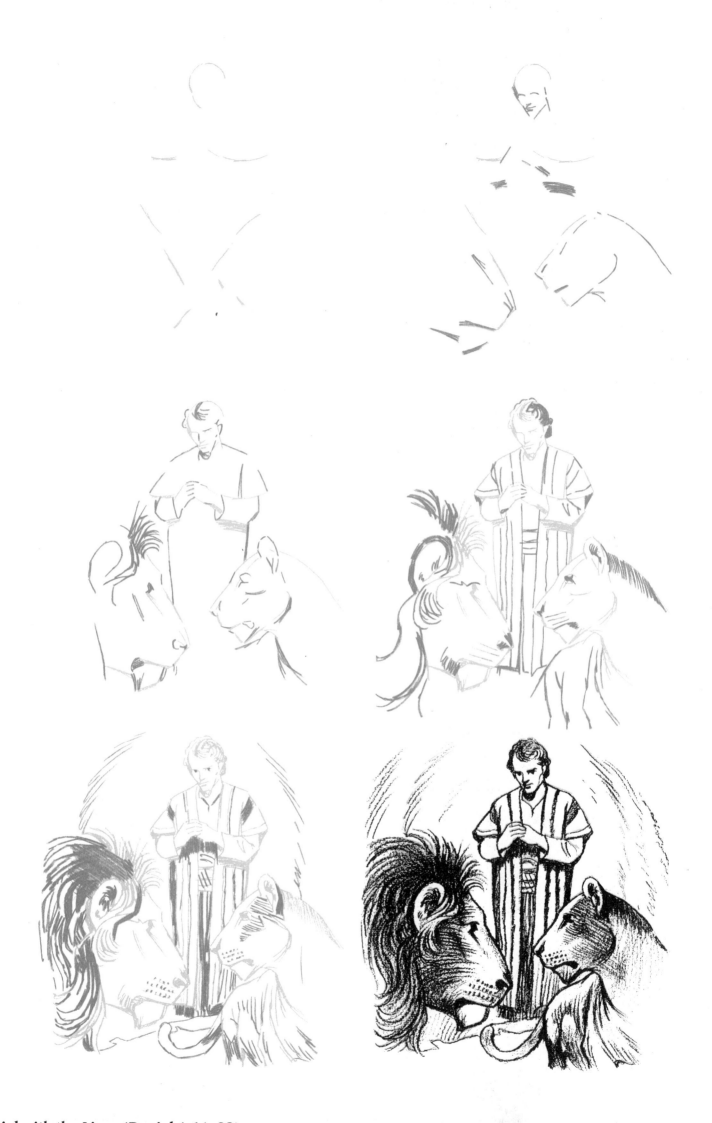

Daniel with the Lions (Daniel 6:16–23)

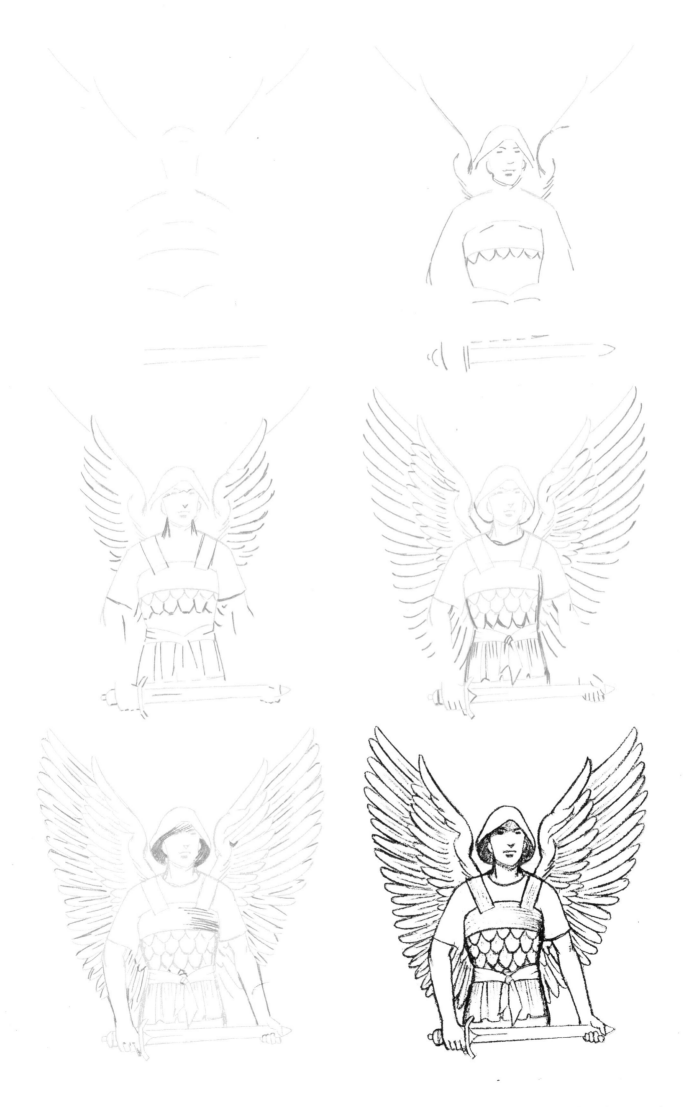

Gabriel (Daniel 8:15–17)

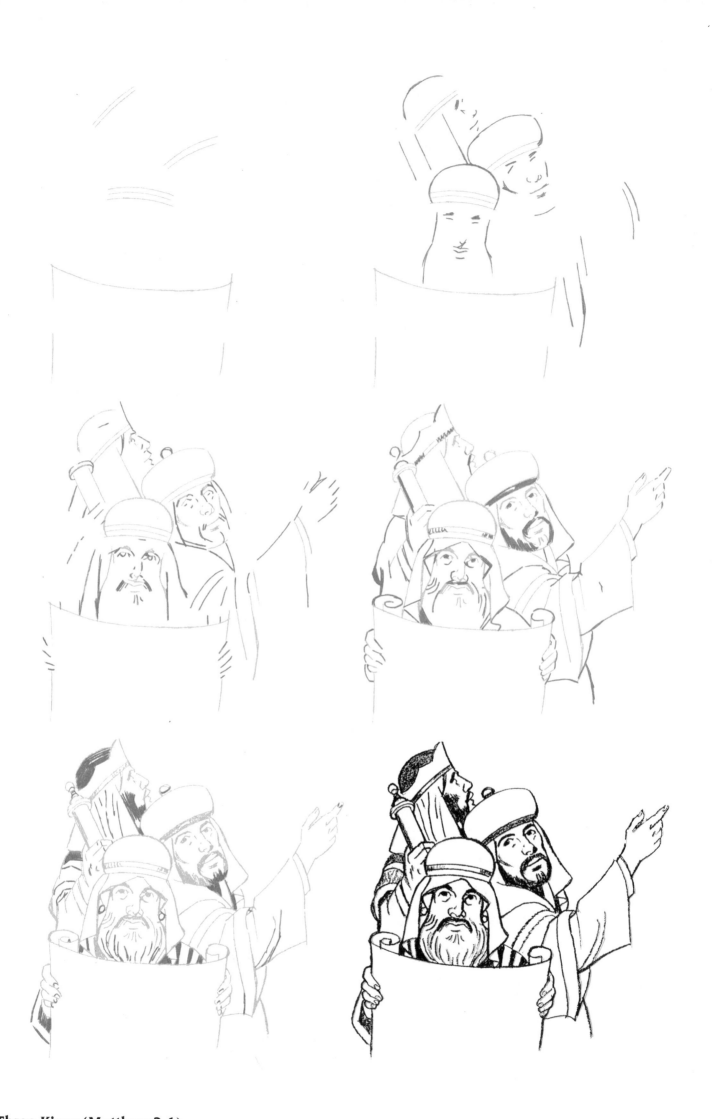

The Three Kings (Matthew 2:1)

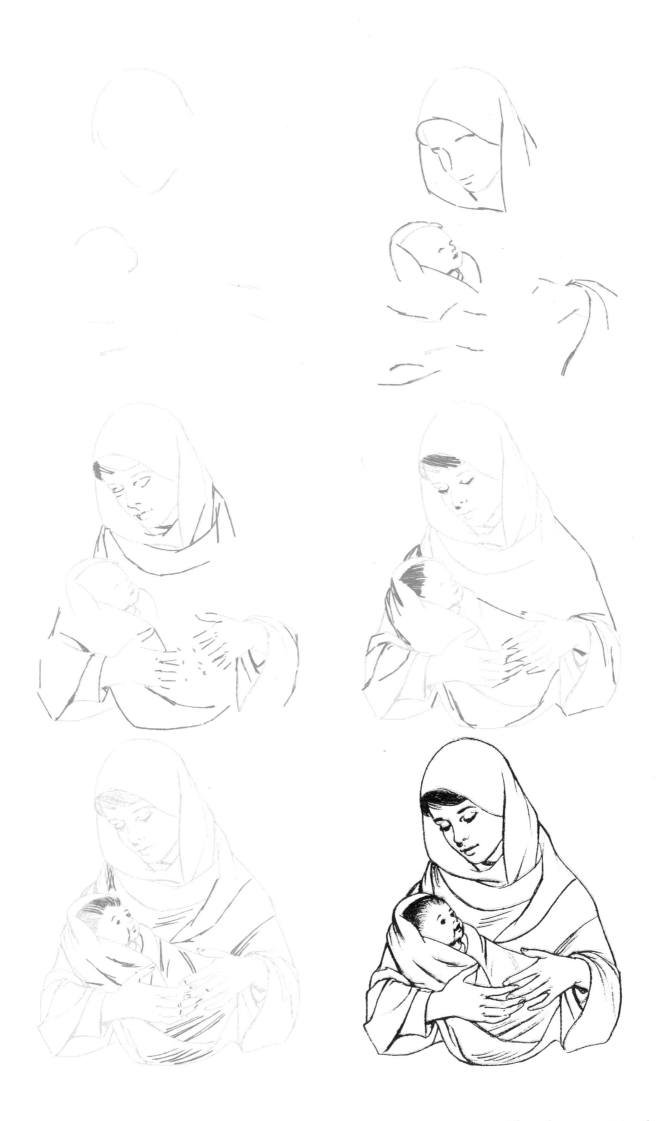

Mary with Baby Jesus (Matthew 2:11)

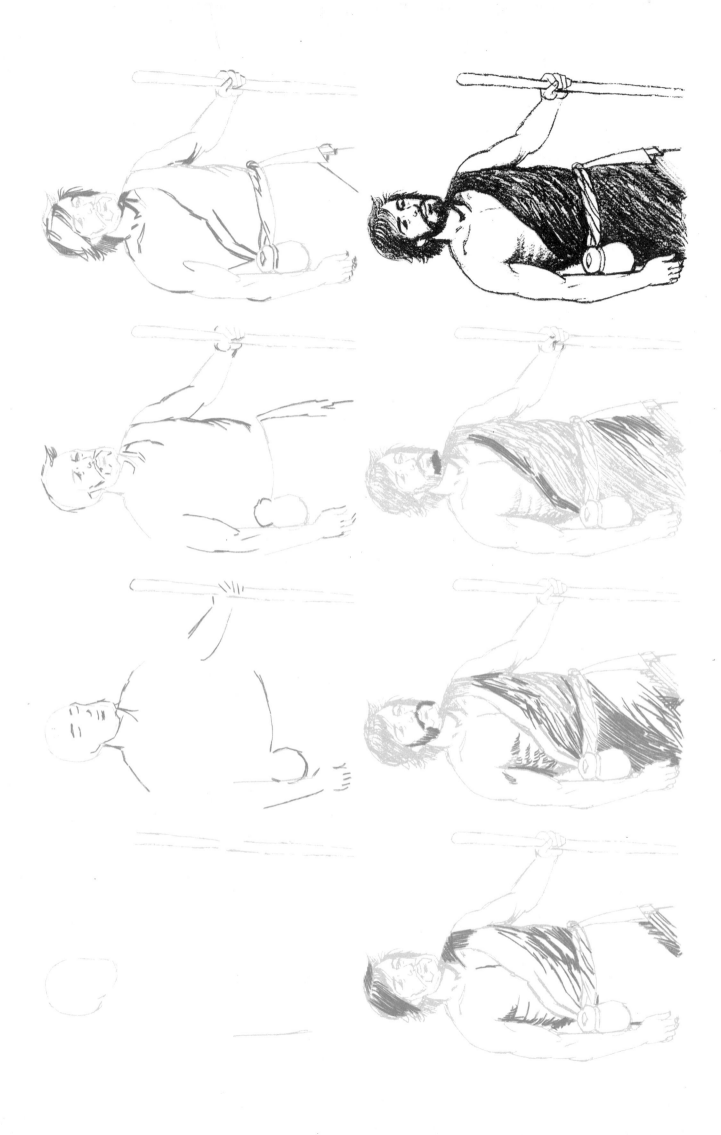

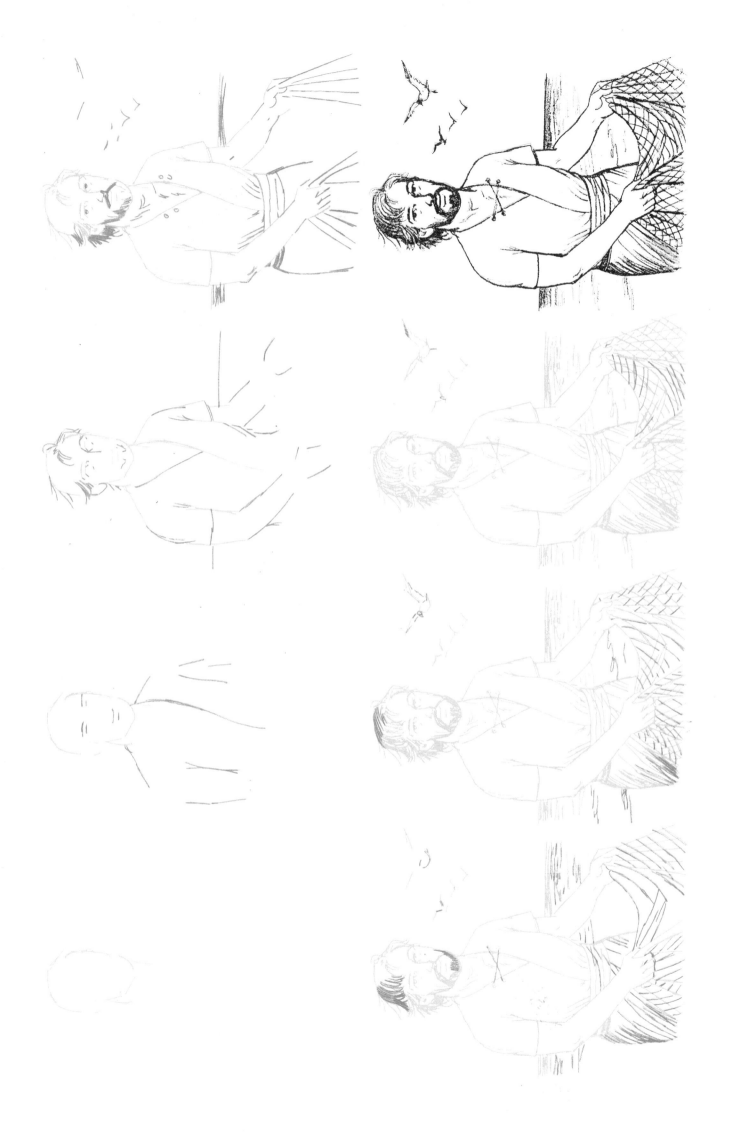

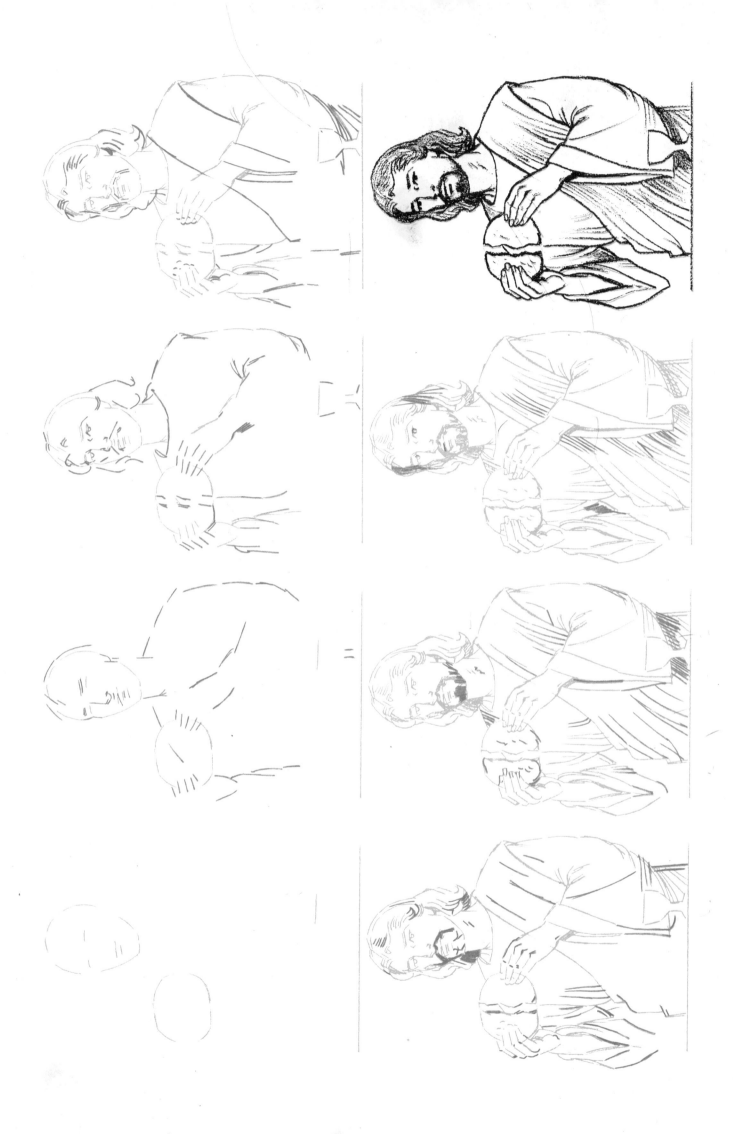

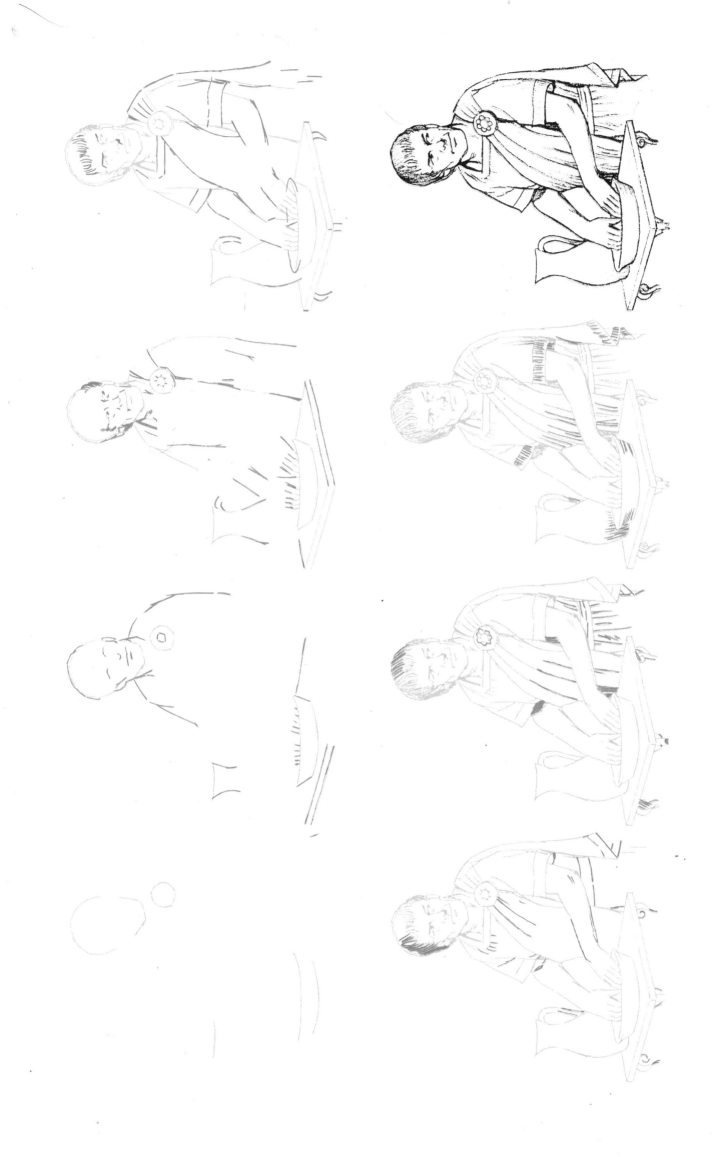

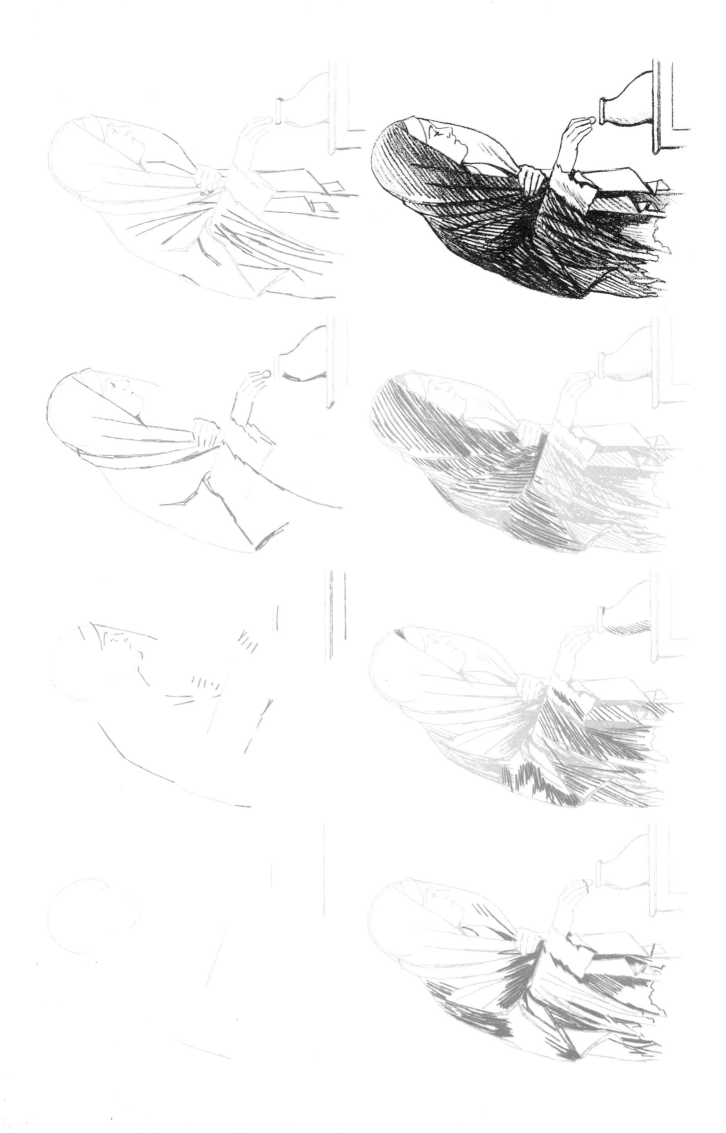

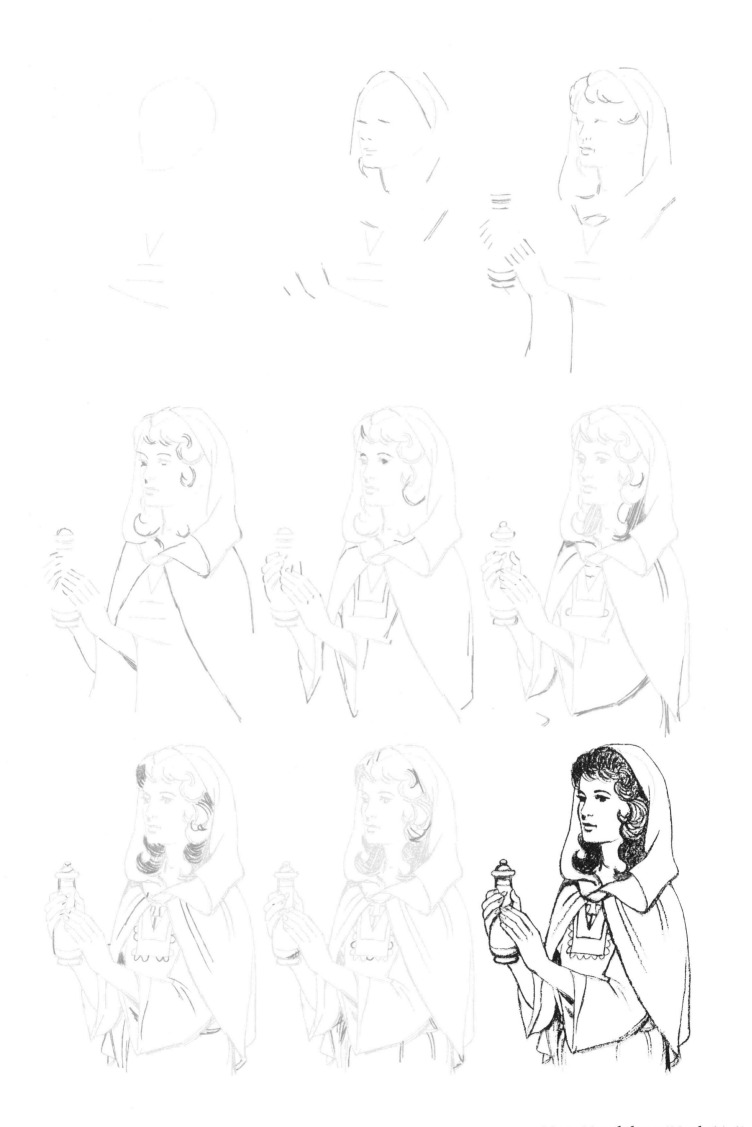

Mary Magdalene (Mark 16:1)

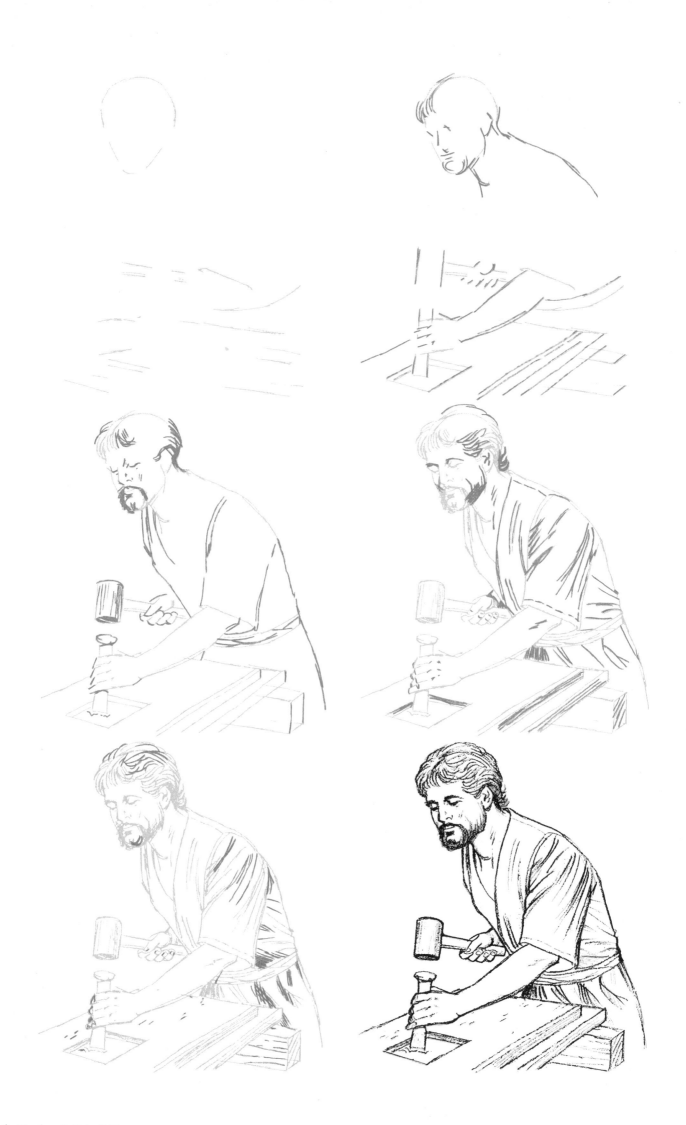

Joseph (Luke 1:26–27)

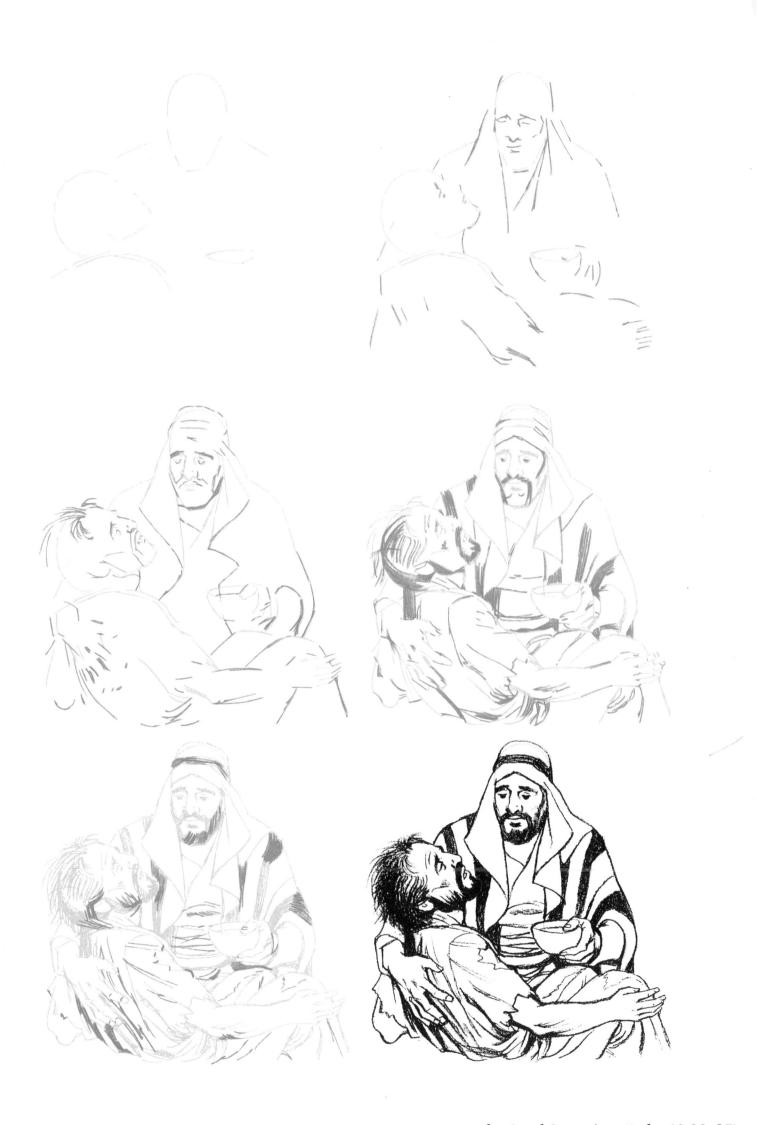

The Good Samaritan (Luke 10:29–37)

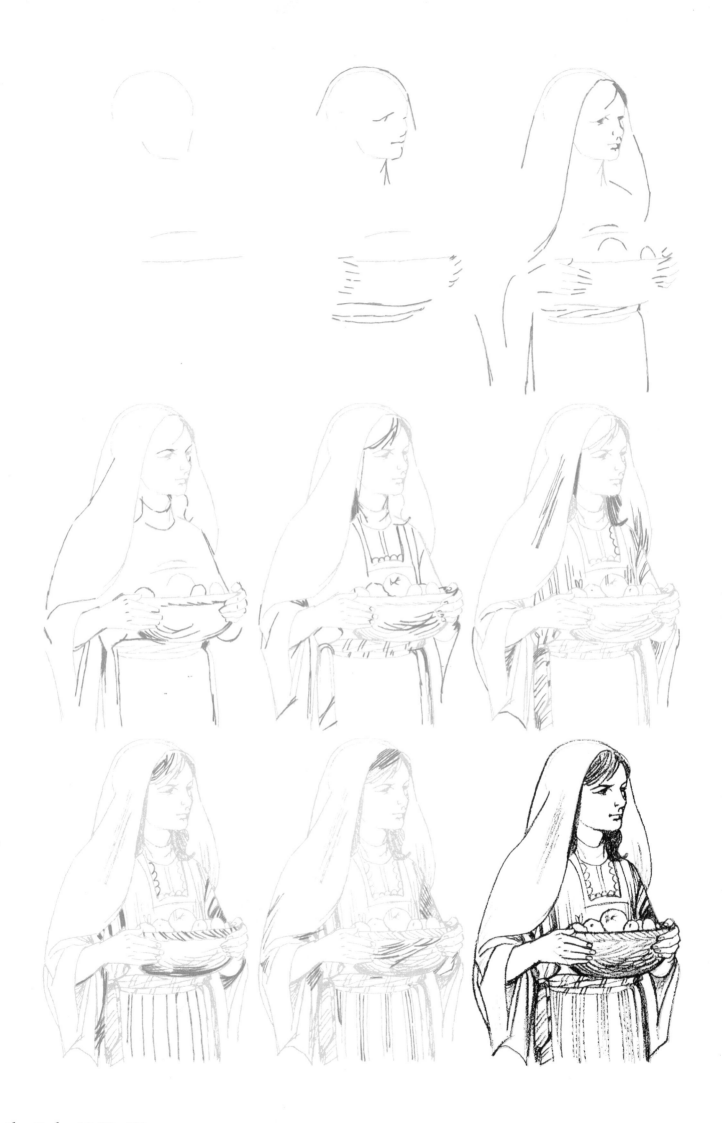

Martha (Luke 10:38–42)

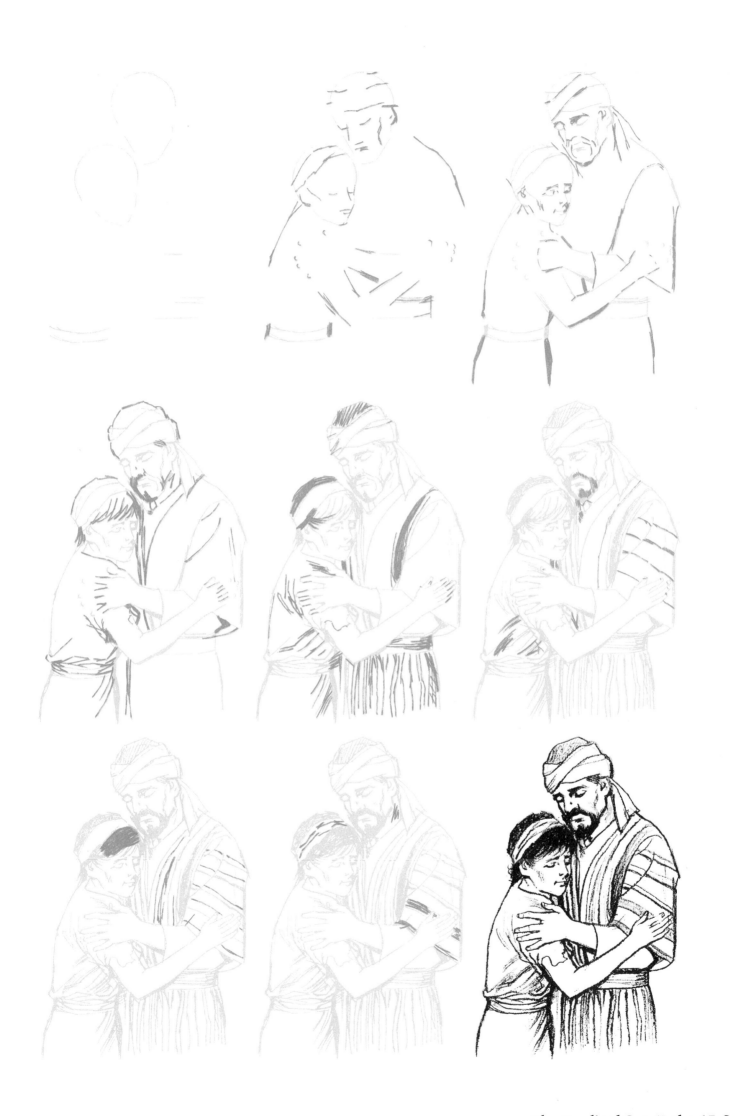

The Prodigal Son (Luke 15: 20)

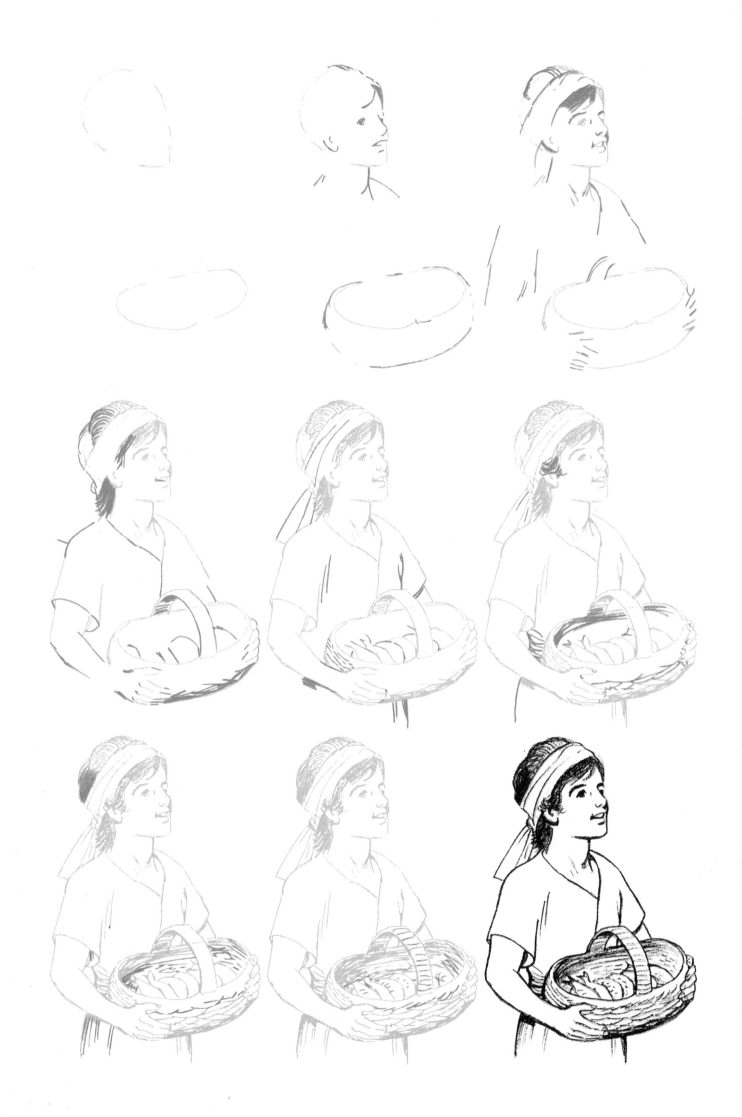

Boy with Basket of Loaves and Fishes (John 6:8–9)

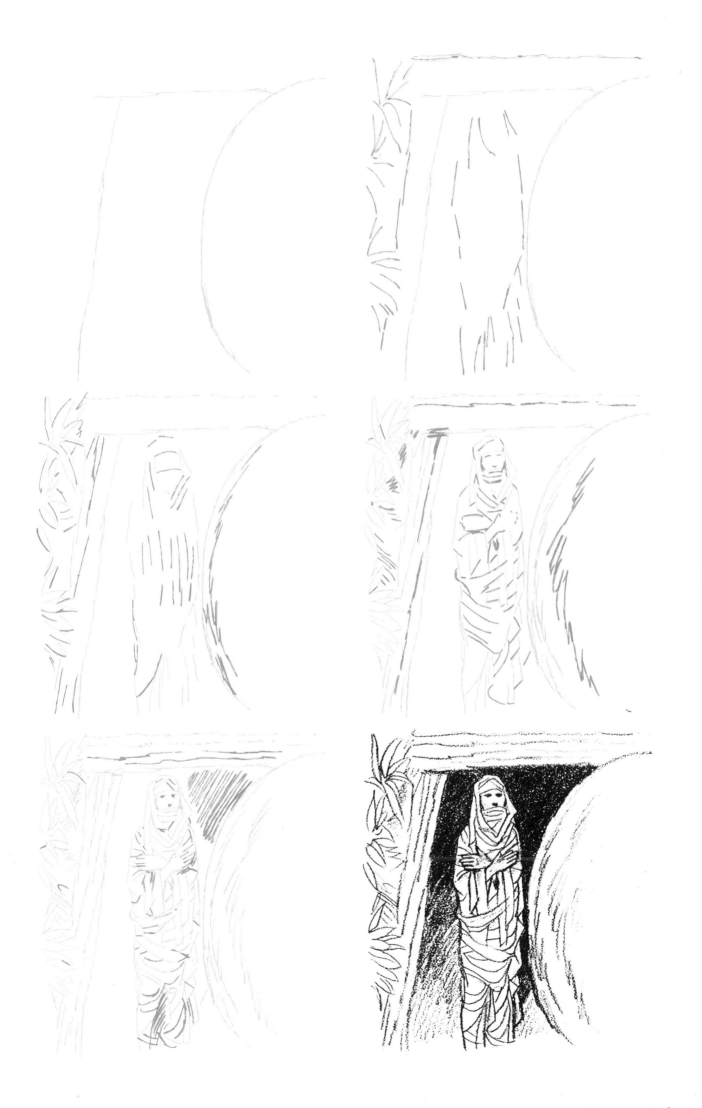

Lazarus (John 12:17)

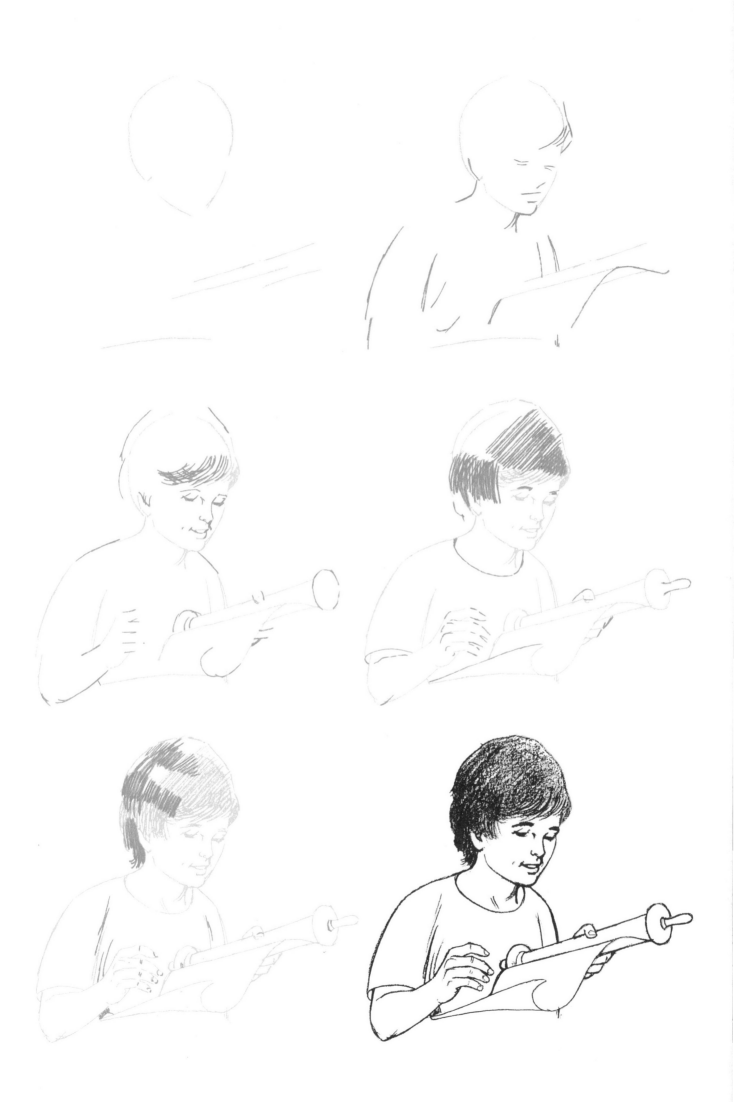

Timothy (Acts 16:1)

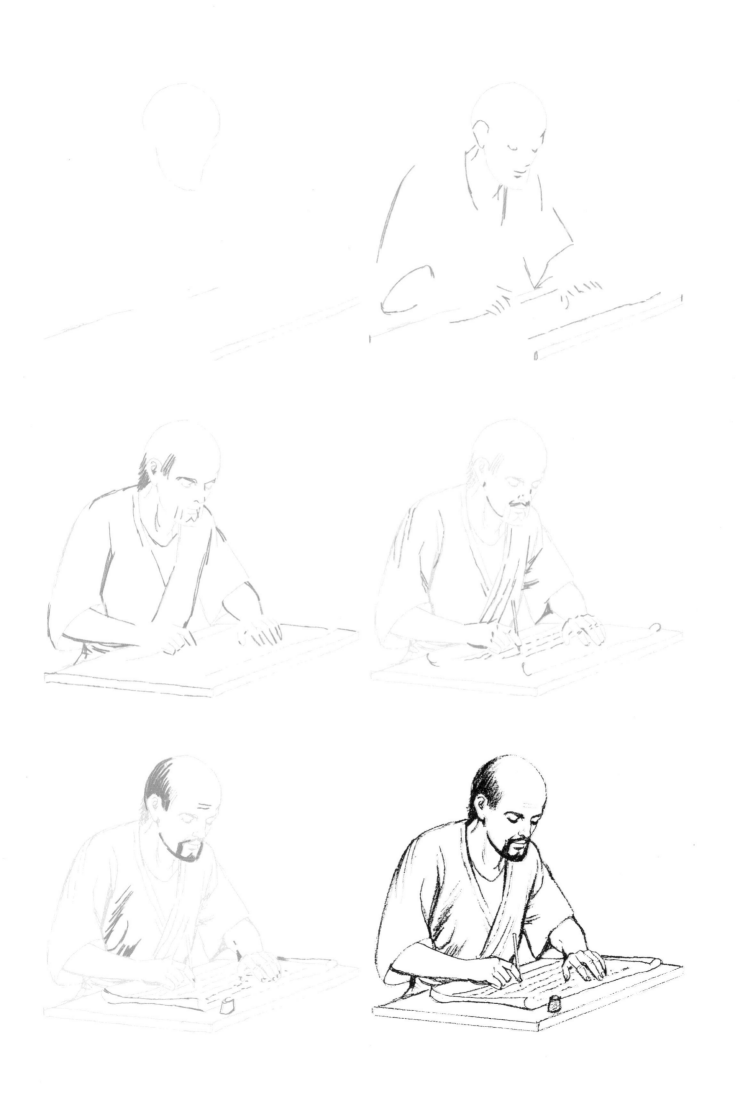

Paul (II Thessalonians 3:17)

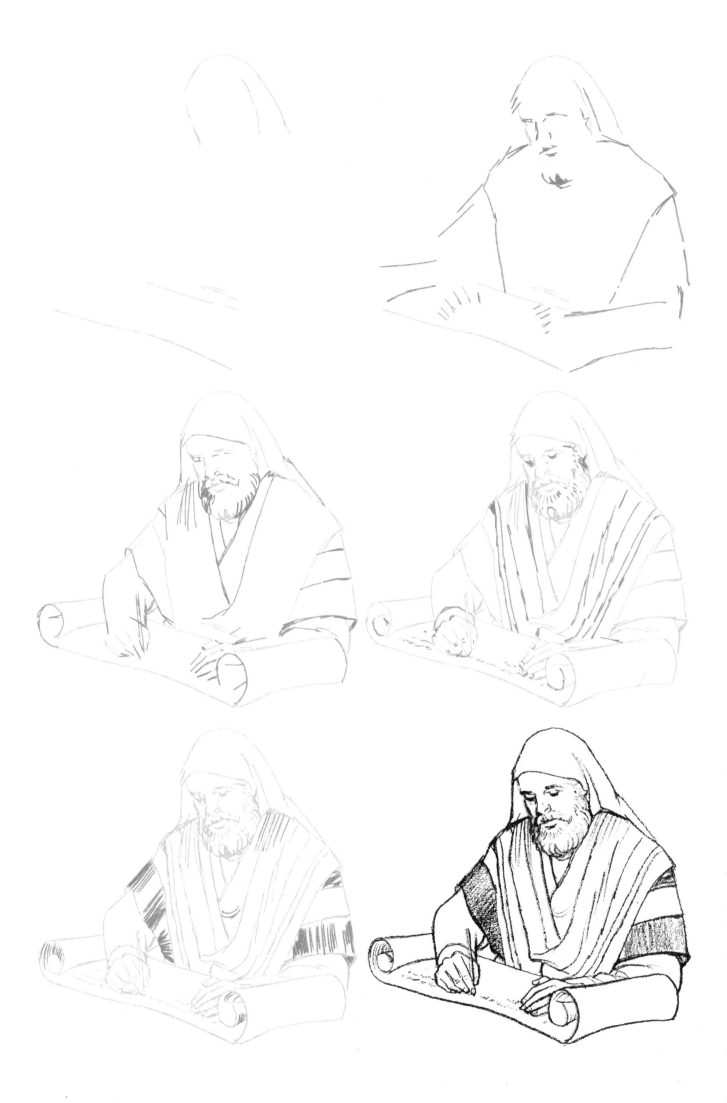

John (Revelation 1:1–3, 9–11)

Lee J. Ames has been "drawing 50" since 1974, when the first Draw 50 title—*Draw 50 Animals*—was published. Since that time, Mr. Ames has taught millions of people to draw everything from dinosaurs and sharks to boats, buildings, and cars. There are currently more than twenty titles in the Draw 50 series, with more than two million copies sold.

André Le Blanc is a graduate of the renowned Art Students League in New York City. He has worked in advertising, magazine illustration, book illustration, and teaching, and he is the artist of the bestselling *Picture Bible*. A world traveler, Mr. Le Blanc has had his stories and art published in magazines and newspapers all over the world, including the London *Times*, *Life* magazine, and *O Globo* in Brazil. He lives on Long Island with his wife.

DRAW 50 FOR HOURS OF FUN!

Using Lee J. Ames's proven, step-by-step method of drawing instruction, you can easily learn to draw animals, monsters, airplanes, cars, sharks, buildings, dinosaurs, famous cartoons, and so much more! Millions of people have learned to draw by using the award-winning "Draw 50" technique. Now you can too!

COLLECT THE ENTIRE DRAW 50 SERIES!

The Draw 50 Series books are available from your local bookstore. You may also order direct (make a copy of this form to order). Titles are paperback, unless otherwise indicated.

ISBN	TITLE	PRICE	QTY	TOTAL
23629-8	Airplanes, Aircraft, and Spacecraft	$8.95/$11.95 Can	× ____	= ____
49145-X	Aliens	$8.95/$11.95 Can	× ____	= ____
19519-2	Animals	$8.95/$11.95 Can	× ____	= ____
24638-2	Athletes	$8.95/$11.95 Can	× ____	= ____
26767-3	Beasties and Yugglies and Turnover Uglies and Things That Go Bump in the Night	$8.95/$11.95 Can	× ____	= ____
47163-7	Birds	$8.95/$11.95 Can	× ____	= ____
47006-1	Birds (hardcover)	$13.95/$18.95 Can	× ____	= ____
23630-1	Boats, Ships, Trucks, and Trains	$8.95/$11.95 Can	× ____	= ____
41777-2	Buildings and Other Structures	$8.95/$11.95 Can	× ____	= ____
24639-0	Cars, Trucks, and Motorcycles	$8.95/$11.95 Can	× ____	= ____
24640-4	Cats	$8.95/$11.95 Can	× ____	= ____
42449-3	Creepy Crawlies	$8.95/$11.95 Can	× ____	= ____
19520-6	Dinosaurs and Other Prehistoric Animals	$8.95/$11.95 Can	× ____	= ____
23431-7	Dogs	$8.95/$11.95 Can	× ____	= ____
46985-3	Endangered Animals	$8.95/$11.95 Can	× ____	= ____
19521-4	Famous Cartoons	$8.95/$11.95 Can	× ____	= ____
23432-5	Famous Faces	$8.95/$11.95 Can	× ____	= ____
47150-5	Flowers, Trees, and Other Plants	$8.95/$11.95 Can	× ____	= ____
26770-3	Holiday Decorations	$8.95/$11.95 Can	× ____	= ____
17642-2	Horses	$8.95/$11.95 Can	× ____	= ____
17639-2	Monsters	$8.95/$11.95 Can	× ____	= ____
41194-4	People	$8.95/$11.95 Can	× ____	= ____
47162-9	People of the Bible	$8.95/$11.95 Can	× ____	= ____
47005-3	People of the Bible (hardcover)	$13.95/$19.95 Can	× ____	= ____
26768-1	Sharks, Whales, and Other Sea Creatures	$8.95/$11.95 Can	× ____	= ____
14154-8	Vehicles	$8.95/$11.95 Can	× ____	= ____
	Shipping and handling	**(add $2.50 per order)** ×	____	= ____
		TOTAL		____

Please send me the title(s) I have indicated above. I am enclosing $_____.

Send check or money order in U.S. funds only (no C.O.D.s or cash, please). Make check payable to Random House, Inc. Allow 4–6 weeks for delivery. Prices and availability subject to change without notice.

Name: _____

Address: _____ Apt. #_____

City: _____ State: _____ Zip: _____

Send completed coupon and payment to:

Random House, Inc.
Customer Service
400 Hahn Rd.
Westminster, MD 21157

BROADWAY